Symbolism and Art Nouveau

Phaidon 20th-century Art

with seventy-three colour plates

Beardsley	Kupka	Rossetti
Bernard	Lechter	Schiele
Blake	Leistikow	Schmithals
Böcklin	Mackintosh	Segantini
Bonnard	Marées	Sérusier
Burne-Jones	Maillol	Strathmann
Crane	Matisse	Stuck
Denis	Mehoffer	Thorn Prikker
Gallén-Kallela	Millais	Toorop
Gauguin	Moreau	Vallotton
van Gogh	Morris	Van de Velde
Hodler	Mucha	Vogeler
Hofmann	Munch	Vuillard
Kandinsky	Petrow-Wodkin	Whistler
Khnopff	Puvis de Chavannes	Watts
Klimt	Ranson	Wrubel
Klinger	Redon	

Maly and Dietfried Gerhardus

Symbolism and Art Nouveau

Sense of Impending Crisis,
Refinement of Sensibility,
and Life Reborn in Beauty.

Phaidon · Oxford

Contents

The authors and editorial staff would like to extend their thanks to those galleries and museums involved in the production of this volume. They would also like to thank the Trustees of the Schmithals inheritance for their permission to publish for the first time the *Weeping Willow by Night* by Hans Schmithals.

Translated by Alan Bailey

Phaidon Press Limited, Littlegate House, St Ebbe's Street Oxford
First published in Great Britain 1979
Published in the United States of America by E. P. Dutton, New York
Originally published as *Symbolismus und Jugendstil*
1977 by Smeets Offset BV, Weert, The Netherlands
German text © 1977 by Verlag Herder KG, Freiburg im Breisgau
English translation © 1978 by Phaidon Press Limited
Illustrations © Beeldrecht, Amsterdam
ISBN 0 7148 1952 2
Library of Congress Catalogue Card Number 79-83784
Printed in The Netherlands by Smeets Offset BV, Weert

The emergence of a wealth of styles

A second wave of interest in the art of the turn of the century was reflected in two exhibitions held in Europe, one in Zurich in 1952, *1900—Art Nouveau and Jugendstil. Art and Applied Art in Europe and America*, and the other in Paris in 1953, *A Century of French Painting— 1850–1950*. These have provided the impetus for a whole series of shows, some devoted to general surveys and others to individual artists or groups of artists. This interest has continued unabated; as late as 1976, for example, a touring exhibition was first shown in Rotterdam with *Symbolism in Europe* as its title, while in Bonn a show was devoted to a single artist, *Carl Strathmann. Jugendstil and the Grotesque*.

The wide variety of styles that emerged at the turn of the century, including not only Symbolism and Art Nouveau but also Neo-Baroque, Neo-Classicism, Neo-Romanticism, and Regional Arts and Crafts, among others, can be tentatively grouped together under the customary heading of 'Stylist Art'. For all these movements were distinguished by their attempt to realize the stylistic possibilities inherent in pure art, handicrafts, and applied art in industry such as would transform man's environment, both public and private. This enterprise was intended to involve the graphic and plastic arts alike, and to exclude no part of the environment. Hallways, staircases, doorframes, and balcony railings; cups, dishes and spoons; the pictures on the wall; all these were just as significant as entrances to tube stations, factory workshops, and railway stations. This belief that stylistic innovation in both functional and pure art had a highly important part to play in the transformation of man's environment finally led to a revolution in style. This remains of the greatest significance for us, culminating as it does in the movements of Expressionism, Futurism, and Cubism, which constitute the finest achievements in the recent history of art. This stylistic revolution also produced a refinement of the techniques employed in applied arts (influenced by the practices of medieval artisans and guilds) and the involvement of artists in the design of products manufactured by industry.

By establishing their independence as movements and the strength of their roots in the 19th century, we can show both Symbolism in the plastic arts and Art Nouveau to be major European manifestations of this trend. That they have influenced, and provided the direct precedents for the experiments, developments, and achievements of the 20th century cannot be doubted if we consider that present-day applied art and industrial design are unthinkable without the fundamental change in approach which took place at the turn of the century. Furthermore, the use of line and decoration in Art Nouveau provided the inspiration for the so-called 'new approach to ornament' which expounded an individual interpretation of early 20th-century art. Symbolist elements can still be found today in literature and in the plastic arts, while in the cinema we have only to think of Ingmar Bergman.

A continuing tendency towards nostalgia has further stimulated people's interest in the art of the closing years of the last century; an interest which is catered for by a large number of exhibitions which are justified and encouraged in turn by the high number of visitors. The

5

more any artistic scene appears to fragment into a mass of confusing and unrelated experiments, the greater the opportunity offered to the interested observer of training his eye to recognize the characteristic hallmarks of major historical trends.

In seeking new means with which to effect a stylistic revolution, artists not only created new needs but also engendered conflict both at the private level and in society at large. A slogan used at this time is apposite in summing up this period of change: 'Whoever speaks of Symbolism, speaks of Decadence'. And *Le Décadent* was in fact the title of an important contemporary magazine, whose first issue appeared on April 10, 1886. The magazine contained an anonymous article addressed to the readers in the following polemical fashion: 'A refusal to acknowledge the state of decadence which we have reached would be nonsensical. Religion, morality, and justice are caught up in a process of decay . . . the increasing refinement of desire, of feeling, of taste, luxury, and pleasure—neurosis, hysteria, hypnotism, addiction to morphine, charlatanism in science, advocacy of Schopenhauer's philosophy to the point of absurdity, all these things are symptoms of a social revolution. The first signs are to be found in language. New and infinitely subtle ideas of every description are creating new desires; and these in turn are making it necessary to coin new words, heard now for the first time and purposely designed to express such a variety of physical and mental impressions' (1).

1886 also saw the publication of the 'Symbolist Manifesto' ('Le Symbolisme') in the *Figaro Littéraire*, by Jean Moréas, a Frenchman of Greek extraction, and it was the same year which witnessed the eighth and final Impressionist exhibition in Paris. Though Symbolism began to make its presence felt before Impressionism had had its day, the main features of the later movement mark it out as belonging to the Post-Impressionist scene and to the transitional period which led into Art Nouveau. The art of this period, in trying to fulfil the needs it created, chose as its principal subject man who, in the solitary and uncertain world of his dreams and fantasies, at the mercy of demonic powers, behaves in a manner at once foreign and enigmatic. A preference for such subject matter led artists to make a break with tradition and to paint pictures embodying a new philosophy of art which no longer regarded the representation of the external world as the prime function of painting.

The first thing that anyone is likely to notice today on looking at the paintings of 'Stylist Art' is that they attempt to transport the observer into another world, which can be so far removed from the one familiar to him that, at first glance, he is unable to gauge the gulf separating the two. This does not imply, however, that any imaginary world created by art bears no relation to the reality in which we live; for it is only when seen against the background of our normal existence that such a new and strange world takes on definition. Therefore it is only once we have compared these imaginary worlds with the real world (and not only in terms of their external features) that we are in a position to ask the question: what are the paintings of Symbolism and Art Nouveau trying to depict? i.e. what aspects of our everyday surroundings are chosen or indeed excluded by them, and what is it about the presentation of these aspects which causes them to appear unfamiliar?

Answers to these apparently straightforward questions are complicated by two factors. One is that the artistic scene at the turn of the century, confusing enough in itself with all its divergent trends, has produced an equally confusing wealth of opinions and ideas as to the nature of its own development. The second is that the situation evidently encourages connoisseurs, professional critics, and art historians to evoke, in highly metaphorical language, the atmosphere of revolutionary change during this period, the pessimistic spirit of the age, and the commitment to aesthetic values, rather than to elucidate the structure of individual works of art and to explain the steps taken by the artists in their creation. They are only too willing (as were their counterparts during the period in question) to draw together incomplete essays in interpretation

and ideas culled from a wide variety of sources and based on anything from subjective appreciation to psycho-analysis: the final product of such endeavours is a dazzling composite analysis which at best is only able to shed a rather diffuse light on the historical situation. Consequently the overall picture of developments in the society and art of the time, and more particularly, the outstanding individual achievements of artists, is distorted and obscured. To isolate motifs which betray the influence of other works is as unproductive as to examine the changing reactions elicited by the paintings since their completion. For this reason we shall not rely on the mere evocation of period atmosphere or on interpretations based on psychological theories and subjective appreciation in order to elucidate the paintings; rather we shall consider what the paintings have to offer when seen in the light of those assumptions we make in our perception of the everyday world. Using particular paintings as test cases—above all Moreau's *Galatea* (Ill. 38), Lechter's *Orpheus* (Ill. 29), and Strathmann's *Maria* (Ill. 57)—we shall establish how each painting is constructed, the message it is trying to convey, and what features of cultural and social conditions are relevant to its creation. This way the observer can, in conjunction with the brief analysis which accompanies each plate, increase, step by step, his critical awareness of what he sees. In so doing he will soon realize that he can learn much more about a painting if he attempts to describe it, rather than merely to observe it. To avoid the danger of the observer being influenced by any preconceptions he might acquire from too much prior knowledge of the history of this period, we shall confront him with the paintings themselves.

Methods of visual organization— how the paintings of Symbolism and Art Nouveau are structured

Gustave Moreau was an extremely successful artist who owed his training to time spent in the studio of the painter F. Picot as well as to the study of the Quattrocento painters (Gozzoli, Mantegna), of Rembrandt, and of the French Romantics, Delacroix above all. He painted the *Galatea* (Ill. 38), an easel picture of medium size, between 1880 and 1881. The artist made lengthy and careful preparations for the composition, his attention being occupied, in the first instance, by the relative positions of the two figures. He drew upon various sources, including the *Actinologica Britannica* (British Lexicon of Actinology) published in London in 1860 by P. H. Gosse. In order to inform himself properly about the non-allegorical parts of the painting, he visited the Jardin des Plantes and the National History Museum in Paris.

Galatea was rated highly by the whole generation of Symbolists, especially by Maurice Denis and Odilon Redon, the latter painting a similar theme, *The Cyclops* (Ill. 48) some twenty years later. But it was only once a new reappraisal of Art Nouveau was underway, and after the great Moreau exhibition of 1961 in the Louvre, that his work was rediscovered.

As unprejudiced observers of Moreau's *Galatea*, we can rely in the first instance on our everyday experience and knowledge, and allow ourselves to be attracted by the richly attired female with an intricate coiffure, who dominates the painting. If we look further, we see a relatively large man's face with an additional eye in the forehead. The head is supported by one hand and is presented to us in implied three-quarter profile. Just as conspicuous are the various kinds of plants, abundant vegetation made up partly of small flowers and partly of large leaves, which cover more or less the whole painting. There are also vine leaves, together with bunches of grapes, framing the man's face. In the vegetation one can also discover some tiny female figures. All these objects—the man's face, the female nude, the vegetation, and the tiny figures—appear before a shallow area resembling a mountain grotto, from which we can see, between the man's face and that of the woman, the suggestion of a vista in the upper half of the picture. A dark expanse of water with a variety of reflected images is visible in the lower half of the picture.

It is unlikely that the observer will have any difficulty in recognizing everything that has been mentioned so far. The painting makes it immediately clear that its subject is neither a lady of high society nor an ordinary woman of no standing nor pretensions. Furthermore, there is no attempt to portray, say, a normal everyday relationship between two people, for those features of the painting which are the most conspicuous, and also the most significant, emphasize the gulf which separates the everyday world of the observer from the artificial world of the imagination re-created in the painting: not only the figure of the cyclops with the eye in its forehead, derived from Homer's *Odyssey* (in the painting we see only its face and hand) but also the rather precious and studied demeanour of the female figure and the extraordinary vegetation. As we look at this painting, we may feel slightly disturbed, even irritated, at being deprived of that immediate understanding of the situation presented to us which we have when looking at realistic paintings. This is because the painting requires the observer to adopt an attitude of mind not in keeping with his experience of the everyday world. This is not simply a question of the observer being prepared to accept winged horses, unicorns, and the cyclops mentioned above, knowing full well that they do not exist. It is the layout, contents, use of colour, and style of the *Galatea* which account for its foreign and hermetic appearance, and seem to contradict the everyday assumptions we make about the world around us. Moreover, the fact that we recognize the various elements for what they are, makes the question of their significance even more baffling.

Though we have provisionally characterized the appearance of *Galatea* as foreign compared with that of our everyday world, the impression made on us by the painting is not solely a consequence of its mythological subject matter. In the same way, the unfamiliar appearance of other 'Stylist' paintings is not simply a result of their subject matter, whether it consist of mythological themes or of equally popular (pseudo-)religious and exotic ones; rather, the peculiar impression they make is rooted in their special manner of execution. That this is the case is evident from a perusal of paintings which are free of the above-mentioned thematic components yet remain enigmatic in appearance such as Klinger's *The Blue Hour* (Ill. 27), Petrow-Wodkine's *Riverbank* (Ill. 44), *The Wave* of either Kupka or Maillol (Ill. 28 and 33 respectively) or Leistikow's *Danish Landscape with Villa* (Ill. 30).

Visual resistance and ambiguity

Continuing to look, then, at Moreau's *Galatea*, and bearing in mind what we have already seen, we cannot fail to notice that the painting contains much more in addition to the elements so far singled out for discussion; indeed, it positively swarms with other visually significant details and components, which we find more and more difficult to distinguish and identify the longer we look at the painting. We are then involved in the unproductive exercise of using a disproportionately high number of words in order to describe (if at all) what we are looking at and achieving less and less accuracy in the process. Finally we are reduced to merely making conjectures about the painting's visual contents. To take another example: in Redon's painting *The Cyclops* (Ill. 48) it is hardly possible to describe or characterize anything else apart from the novel invention of the one-eyed monster peering over a rock face into the picture from high up on the horizon, and a female nude lying in a shell-shaped hollow in the rock. Nevertheless, the event taking place on the canvas is disturbing enough for us to scrutinize those parts of the picture composed of small scale configurations for clues as to an interpretation. The same is also true, for example, of Strathmann's *Maria* (Ill. 57), where the number of details waiting to be discovered seems never-ending. As we look at such paintings, we are never quite able to rid ourselves of the uncanny sensation that despite all our attempts at description we have not managed to discover what the painting is 'really' about. In other words, no amount of description

8

seems to exhaust the wealth of possible interpretations suggested by the subject matter so that in this sense, at least, we are justified in speaking of the surplus of visual detail characteristic of paintings executed in this fashion. In the same way we can say that the painting stimulates our vision in as much as it engages and holds it at the level of the picture surface. The constant interplay between elements whose identities are either quite evident, or open to a variety of interpretations, or even, as is often the case, simply ambiguous, means that the eye's attention is entirely devoted, at this stage, to absorbing visual detail and is therefore unable to progress directly from this to an interpretative stage. It is almost as if paintings of this type, by virtue of their mass of detail, purposely obliged the observer to take time over his examination.

This concept of visual delay requires further elucidation. It is essentially a result of the eye being compelled to follow the treatment of the objects and the details in the painting. As it does so, the eye relies much more on tactile values than on features which create a sense of depth, such as the solidity of objects and their arrangement in space. Furthermore, the painting endeavours to make a well-defined division of its material into self-contained phenomena (this is quite apparent in the case of the cyclops' face in Moreau's *Galatea*). Consequently, what the painting offers is not a unified and complete visual experience but a number of distinct visual phenomena whose individual identities are more apparent than any connections they might have with the whole, although these are not entirely absent. This concept of the 'narrow focus' is an integral part of the composition in Symbolism and Art Nouveau. It neglects the individual features of objects in favour of those which are purely typical. It is not concerned with either particular people as individuals (except of course, in the case of portraits such as Klimt's *Portrait of Elisabeth Bachofen-Echt*, Ill. 25), or with particular facets of the visible world, but rather with an archetypal woman as in the works of Rossetti, Stuck, and Hoeller, among others, and with an archetypal landscape as in Leistikow. The method of 'narrow focus' composition embodied in these paintings obliges us to establish connections and affinities between individual objects in order to appreciate them, rather than to try and discover which details of individual figures have been as faithfully rendered as would have been in realistic (or naturalistic) paintings.

The painting in question, Moreau's *Galatea*, confirms this visual approach, for here, as well as in many other Symbolist and Art Nouveau pictures, the surface is divided into two equally autonomous areas which are clearly set off from each other. One area is articulated by means of larger components and the other by means of smaller components. The successful interplay of the two areas is not merely a result of avoiding the solidity which creates a sense of depth, nor is it achieved by the lack of a three-dimensional arrangement of objects, nor by neglecting aspects peculiar to each object; rather is it a consequence of the 'narrow focus' compositional method being applied to both areas so that they produce a flat and coherent picture.

In this context, what is meant by the 'small-scale articulation' needs further elucidation. The term refers to the points and tiny patches of colour which appear in Moreau's *Galatea* and in Redon's *The Cyclops* (Ill. 48), to the abundance of tiny leaves and small fruits in Mehoffer's *The Strange Garden* (Ill. 35), to the large number of pebbles in Gallén-Kallela's *The Mother of Lemminkainen*, and to the accumulation of the most varied detail in Puvis de Chavanne's *Hope* (Ill. 45). Whereas the Impressionists applied colour by means of points and dashes in order to dissolve the objects depicted in their paintings into a mass of variegated colour particles, the 'Stylists' endeavoured to structure the area of small-scale articulation by using small and very small objects and parts of objects. Now it would be beside the point to study, say, each tiny pebble or spot of colour for without the rest of the painting they remain tiny pebbles, patches of colour, and luminous points whose sole function is to divide up the surface. The applied art technique used in the laying of mosaics made up of different coloured stones or glass fragments has a long tradition behind it and was of particular interest to Klimt, for example. Moreover, the effect pro-

duced by small, irregularly shaped fragments of different sizes which are not incorporated into a large scale pattern is one of rhythmic interweaving and intricacy in the areas of small-scale articulation. This intricacy is created by fragments ordered in part in an illusionistic fashion, in part in a non-representational fashion, and by a combination of both techniques. This procedure, used to the same effect not only in the laying of mosaics but also in painting (*Galatea* provides an illustration of this), finds its most extreme expression in the painted mosaic of Strathmann's *Maria* (Ill. 57), in the accumulation of the most varied elements in Knopff's *Isolation* (Ill. 22), and in Mehoffer's *The Strange Garden* (Ill. 35). Klimt transformed the use of decoration, raising what was originally a skilled craft to the level of art. He successfully reduced the scope of large or small-scale articulation in *Salome* (Ill. 23), and *The Kiss* (Ill. 24), without, however, destroying the identity of either image.

The techniques we have discussed so far have clearly been mutual sources of stimulus and influence. In that they retard and extend the process of observation and pose special problems for our powers of perception, their combined effect is one of 'visual resistance'. The bizarre colour schemes serve to reinforce this effect. Like subsequent 'Stylists', such as Böcklin and Stuck, Moreau is also ready in *Galatea* to neglect or even abandon the local colouring appropriate to each object in order to create a mysterious and ominous darkness. By using pure colours of equal intensity Gauguin, for example, and the Synthetists endeavoured to emphasize flat forms, simplicity of layout, and, by the same token, outline and decorative continuity. Denis, on the other hand, produced surfaces covered with bright pastel colours in order to underline a contrast with the background whose paleness swallows up any sense of animation. In his painting *The Blue Hour* (Ill. 27), Klinger makes the functional importance of colour a theme in its own right. In *The Wicked Mother* (Ill. 53), and in other paintings exemplifying a similar manner of execution, Segantini succeeds in making thematic use in monochromatic blue of lifelessness, unreality, and rigidity.

Before leaving the subject of visual resistance, a phenomenon which we find both in Symbolism and Art Nouveau, let us add one final comment. Visual resistance does not permit us to read off the details of a painting one by one and thus to derive satisfaction from recognizing them again, rather are we obliged to see them in the context of the whole; nor does visual resistance allow us simply to look at what is in front of us and confirm its identity. The mutual affinities of the objects depicted and their proximity to each other, their 'altogether-ness', create a work that is self-contained, a work that is realized in the medium of painting and strives to elude direct translation into another medium such as that of language. This does not imply, however, that attempts at a verbal definition of the painting's character are excluded; on the contrary, they are invited without our being able to opt for any one definition and be satisfied with it. The following quotation, taken from the art historian H. Bauer, will serve as a general conclusion to all this: 'If "works of art" are reality, then they can be experienced through language, that is conceptually, provided that they are intended to be experienced as concepts' (2). The hermetic character of Symbolist paintings is not so much a result of the frequent lack of sufficient mythological or literary knowledge possessed either by present-day observers or their counterparts at the turn of the century, but as a consequence of the special degree of tension which exists between the painting and the observer's ability to express its meaning.

Methods of open composition and the thematic use of material qualities

Referring to 'Stylist Art' in general, and to Symbolism in particular, H. H. Hofstätters spoke of the 'impossibility of a definitive interpretation of Symbolist paintings or even of one approaching completeness' (3). In making a statement of such critical value he showed himself to be one of

the finest connoisseurs of 'Stylist Art' at the turn of the century, as did A. Hauser when he referred to its 'ambiguity and varying interpretability'. It will only be possible to verify or contradict these complementary statements if we can draw some definitive conclusions from the present analysis. And to do this, we must further clarify methods of pictorial construction and produce evidence in support of our deductions. At the same time, an accurate and lucid treatment of the individual techniques used to organize the elements within a painting, and make their relationship to each other readily comprehensible, is more important than a discussion of the intricacies of a painter's compositional strategy. Our first priority, then, must be to discover by what methods of pictorial composition the 'Stylists' succeeded in evoking an atmosphere of uncertainty and ambiguity in their works, appropriate to the message they sought to convey, and which gives rise, at the same time, to changing interpretations.

If we were to peruse a selection of paintings representative of the western tradition, we would discover that, in general, pictures are painted in a manner which permits satisfactory answers to questions concerning the time and place of the situation portrayed, the positions of the objects and their relationships to each other in the light of a possible interpretation of the whole painting.

In the *Galatea* we soon encounter questions of this kind: what exactly is the nature of the situation here? When does it take place? What is the nature of the location in which the figures find themselves? What are they doing? What is their relationship to each other? That such questions can be raised by a careful study of the painting and yet not be provided with adequate answers, is the result of various factors, in addition to that of visual resistance: for instance, compositional procedures which seek purposely and carefully to obscure elements of time, place, and nature of the action, and to remove them more and more from view. Thus we gradually lose all points of reference with which to orient ourselves.

In Khnopff's *Isolation* (Ill. 22), it is scarcely possible to make out anything definite about the time or place. The location of the figure which dominates the painting is consciously withheld from us by means of the artful overlay of elements, and the careful inclusion of the figure in a full-length format. Furthermore, once we begin to wonder whether the figure in black is standing or sitting, we find ourselves uncertain as to the answer; behind the figure a chair is at least implied, which would explain the manner in which the right arm and hand are held and also the distribution of light and shade on the dress. The way in which the object in the left hand is held makes us uncertain whether it represents a sword, a sceptre, or both; and yet we can only solve the question of the figure's identity once we have managed a correct interpretation of the striking accessories in the painting such as the glass sphere and the flower-like formation on a long stem. For these objects certainly do not belong to the category of fixed iconographical conventions as, for example, do the 'vanitas' or still-life symbols in Gallén-Kallela's *The Mother of Lemminkainen* (Ill. 13), or in Böcklin's *Self-Portrait with Death playing the Violin* (Ill. 6).

In addition to their preference for very narrow vertical and horizontal formats (e.g. Klimt's *Salome*, Ill. 23; Crane's *The Horses of Neptune*, Ill. 9), Symbolist and Art Nouveau painters also chose broad horizontal and vertical ones, tending more and more to the shape of a square (e.g. Klinger's *The Blue Hour*, Ill. 27; Munch's *Chamber of Death*, Ill. 42). Popular too were the formats in which the top corners were rounded off as in altar-paintings (Millais' *Ophelia*, Ill. 36) or those tending more to the shape of a circle (Khnopff's *Mystery and its Reflection*, 1902, among others), or of an oval (e.g. Segantini's *Goddess of Love*, 1894–95).

Until the emergence of the De Stijl artists Piet Mondrian and Theo van Doesburg the compositional layout of an easel-painting was determined by the external boundary of the frame. Traditional compositions aimed to achieve balance by giving equal importance to all parts of the picture: when, for example, an object is placed in one corner, the contents of the other

corner are to be arranged in a complementary fashion so as to maintain a balance between elements of differing importance, shape, and colour. Once the individual element is seen to add to the layout of the whole, then only does it attain its *raison d'être* and this it is unable to do by itself. Each individual component, then, is justified in terms of the contribution it makes to the whole, which in its turn imposes order by distributing weight equally among the parts.

In terms of traditional methods, the function of the over-sized man's face remains uncertain inasmuch as nothing else in the painting corresponds to it either in shape, outline, colour or position. Yet we do not have the impression that it does not belong in the picture. Rather do we see ourselves obliged to consider more closely the compositional rules which make the image appear incomplete in terms of the pictorial organization. The question of the painting's composition can be posed more accurately thus: how is the continuity of the different elements achieved and maintained? Or put another way: how is the picture balanced out? Our search for some compositional scheme, in common use and implemented here, is likely to be in vain. We may of course choose to regard the female nude as proof of a diagonal line which runs from bottom left to top right and thus divides the painting, roughly speaking, into two triangles. Moreover, there is no doubt that the location of the female figure is further emphasized by the dominance of the light yellow flesh colour over the rest of the palette, which places the nude in a central position. But what, in terms of the painting's structural division, is the role played by the frayed strands of fair hair running parallel with the picture-frame and echoing the flesh-colour? And what is the function, seen in the same light, of the direction indicated by the hand which is held in a resting position on the left side of the head? Is the interest of the painter really concentrated on the nude alone?

If we disregard for a moment the significance of the allegory, we can follow a compositional line which begins on the right at the strand of hair placed parallel with the frame. This line extends around the right shoulder of the nude in a clockwise direction, using it as a turning point, until it reaches the top edge of the picture frame. The obtuse angle thus formed is filled with segments of varying sizes, each of which opens out to the bottom. Their boundaries run approximately thus: the strand of hair and the outline of the nude's right hand side; the outline of the nude's right hand side and the diagonal formed across the body by a line running from the tip of the outstretched foot to the right shoulder; the diagonal formed across the body and the left arm (as we see it) of the nude; the left arm and the hand with which the man supports his face. If the strand of hair forms one side of the obtuse angle, its other side is formed by the bent right forearm (as we see it) of the female figure along with her head and the man's forehead. This eccentrically shaped plane which disregards the relative importance of the elements it encompasses, can be described as a fan in the process of being slowly opened out, or even better, as shafts of light radiating from a common source. Understood in this way, the shafts of light have value with respect to the alignment and compositional layout of the painting. The nude's right arm, which is bent at a pronounced angle, passes through the pivot of this eccentrically shaped plane and at the same time extends the radial articulation of the surface as far as the right hand side of the frame. As we observe this process, we can imagine the continuation of each shaft of light to the edge of the painting and beyond it. This results in an openness of composition in all directions so that the external boundary imposed on the picture by the frame appears to be fortuitous rather than necessary.

This two-dimensional fan-like figuration emphasizes the significance of that part of the surface devoted to the allegory, rather than giving equal weight to all sections of the painting. It therefore stabilizes the position of the allegorical area with respect to the whole, and at the same time makes the relationship between the man's face and the nude comprehensible in

compositional terms. Furthermore, not only the fan-like structure ensures that each figure is allotted an incidental, indeed random position, but the fact that there is only an approximate correspondence between the figuration and the outlines of the objects underlines the chance nature of the positioning.

This fan-like articulation also fulfils the same compositional function in other paintings by Moreau, such as *The Apparition*, and in a modified form it can be seen in the paintings of many other 'Stylists', such as in those of Gallén-Kallela (Ill. 13), of Munch (Ill. 43), and of Gauguin (Ill. 14). It proves how much these artists disregarded tradition. Models for fan-like figuration can be found, for instance, in the paintings of the Romantics for whom the Symbolists had a high regard. Such figuration is foreshadowed in the work of C. D. Friedrich (his *Wanderer across the Sea of Mists* illustrates this technique) though other elements are still used to create a sense of compositional stability. What is particularly striking in this case is the manner in which the shape of the frame is employed in a very subtle way to consolidate the layout of elements on the surface. Consequently their displacement within the painting is excluded as is any extension of the frame itself. In the works of Moreau, however, as in Puvis de Chavannes' *Hope* (Ill. 45) this is entirely possible and conceivable; we find it also in works which do not use radial composition such as Sérusier's *Melancholy* (Ill. 56) or Lechter's *Orpheus* (Ill. 29).

Radial composition undoubtedly ensures a certain clarity but it does not guarantee the creation of balance. The methods of pictorial organization so far described and other techniques of open composition such as the horizontal stratification of areas as in Bernard's *Madeleine in the Bois d'Amour* (Ill. 3), Gauguin's *Loss of Virginity* (Ill. 15), and Puvis de Chavannes' *The Summer* (Ill. 46), or the arrangement of elements in vertical rows as in Lechter's *Orpheus* (Ill. 29), Crane's *Horses of Neptune* (Ill. 9), give the feeling that not only is the choice and location of elements fortuitous but that they are also not solidly placed in space.

The technique of open composition would have little effect on its own were it not for the presence of additional factors affecting the lack of solid placing and weight of the figures themselves, and other pictorial components. In the period of transition leading up to Art Nouveau, the technique of open composition resulted more and more in two-dimensional patterns made up of a network of interrelated components. Pictorial conceptions such as those of Lechter (Ill. 29), and Strathmann, are ample proof of this.

Returning once more to *Galatea*, there appears to be one aspect that we have not yet considered at all, which might well be bound up with the glittering luminosity of the colours, the iridescent quality of the light over the whole canvas, the wispy and frayed nature of the hair, the ripples and indentations (behind the nude, for example), the fabric-like texture of the setting with its vegetation, water, tiny figures and other elements. In contrast to the allegorical part, the area of small scale articulation appears translucent, loosely structured and almost formless, and is rich in figuration and detail. This accumulation of fine details is produced by the depiction, minute in parts, of flowers and shoots, painted with dashes of colour on a dark background (beneath the nude's thigh, for instance) and by the further inclusion of other scarcely noticeable details. Linked with this is a reduction in the density of pictorial elements, creating a porous surface which appears transparent. On the other hand, in contrast to the area of small-scale details, the nude, face and hand appear relatively solid yet not completely unyielding; though related in terms of their shape and relatively large areas, they are not sharply defined nor well differentiated as regards the shapes of their inner parts. It is only the two-dimensional character of the small scale area which, by contrast, makes the large scale areas appear relatively solid. At the same time the essentially rounded forms seem soft and yielding rather than concrete and three-dimensional. The light is diffuse, the shadows not sharply outlined. Because of the wealth of figuration and detail surrounding the allegorical area, and

because of its yielding, soft, fluid, and unstable appearance, the painting acquires a uniformity of character which unites both areas and which we can describe as its material qualities or 'materiality', a term first used by R. Hamann in the 1940s.

In addition to the latter concept, there are two further fundamental notions of equal importance: the tactile 'narrow focus' factor, which aims to give firm and clear definition to pictorial elements by using shadow to mould contour, lines, and volume; and the complementary 'wide focus' factor which ignores the tactile aspects of the picture, concentrating instead on complete images which merge individual details and present the eye with a unified whole.

The Symbolist view of painting was dominated by the material qualities of the objects represented in the painting; that is, if a painter decided to paint the human body, he focused more on the round, fluid, often light and shifting qualities of its form rather than on its anatomical structure presented in terms of the distribution among its parts of stress and load.

This compositional procedure which aims to give the objects the appearance of lacking solidity, was first used by the Pre-Raphaelites, for example by Rossetti (Ill. 50). Its gradual growth in popularity can be deduced from its appearance first in the work of Denis (Ills. 10-12), and finally in Redon (Ills. 48, 49). This concern with the material qualities of objects rather than with their form or the meaning they convey explains how in less successful paintings the picture often appears empty, the palette anaemic, and the composition downright banal.

The material qualities used by Symbolist artists to depict the subject matter of a painting are employed non-representationally in Art Nouveau, indeed they become the subject matter itself, as is the case in Strathmann's *Maria* (Ill. 57). Here the physical qualities of the objects reflect the interest in the techniques and materials of the applied arts. In the same way Strathmann's intention is to create a whole out of a wealth of tiny components, and in the process the figure of Mary—traditionally the centre of interest in a painting—becomes indeterminate in outline and thus obscured, or at least simply one element among many. Moreover, the identity of the figure is only made clear by the half-veiled face and the folded hands. It appears as a sagging two-dimensional shape without substance which seems to be on the point of sliding out of the bottom of the painting, and is very similar, in fact, to the flat column in the top left-hand corner, to the candle to its right, and to the letter-like flourishes in the bottom left-hand corner. Even after close study of the painting it would be hard to describe from memory, even in approximate terms let alone accurately, the many shapes to be found here and the patterns created out of them; and this is true despite (or precisely because of) the fact that everything from the veined marble column to the filigree contents of the large halo above Mary's head, including the decorative shapes on the burning candle, is painted and fashioned with the express purpose of producing flattened perspective and uniformly fine detail. It is through those paintings which treat the material qualities of what they depict as their theme that we can understand the desire of Art Nouveau painters not to admit of any distinction between applied and fine art.

Segantini, using the pointilliste technique of colouring as his starting-point, succeeded in producing another variant of the compositional procedure which deprived objects of both their definite placing within the painting and their material qualities. He continued to apply paint in dots, dabs, and dashes until the allegorical figures seemed on the point of merging once again into the amorphous mass of colour.

Further examples of another variant of this technique are represented by two works of Thorn Prikker, *Deposition from the Cross* (Ill. 60), and *Madonna in a Tulip Field* (Ill. 59). All the objects represented in Thorn Prikker's work are a product of the pattern and compactness of the texture, which resembles in some places strings of pearls and in others pieces of fabric. Broad contour, however, is still used for the articulation of the larger units in the painting.

The Symbolist method of open composition is employed by Lechter in his *Orpheus* (Ill. 29)

to produce a flattening row-like arrangement of pictorial elements. Although this deprives the painting of any sense of depth, it helps to create the impression that the layout is not solid and its elements are shifting. Because the painting's character is conceived essentially as an act of decoration it appears to have been the result of a child using single flowers to lay a carpet which can be trodden on and upset at any moment and thus is not likely to survive for very long. In such a painting the predominating physical impression created by the objects is one of ephemerality, delicacy, and fragility, as in the case of the figure of Orpheus himself.

Interplay of pictorial elements rather than realism in the use of detail

The layout of Symbolist and Art Nouveau paintings does not always allow the perceptual assumptions we make about our everyday world to go unchecked. The organization of the pictorial elements we see does not always coincide with our expectations. This is the case where the method of open composition, with the possible use of fan-like figuration, and the emphasis on material qualities are used either representationally or thematically to undermine the sense of solidity and balance of the whole painting or part of it. In our perception of the everyday world we are accustomed to orient ourselves first of all by means of the bodies themselves as well as by means of their parts, that is, their qualities and characteristics. 'Stylist' paintings, however, go beyond this process of orientation by means of visual attributes, which for us is perfectly natural. The artists, whether they are in the process of emphasizing, for compositional purposes, the material properties of the objects they are depicting, or whether for the same reason they are organizing the elements, concentrate in both cases on the correspondences between the figures, objects, and other elements portrayed. Porosity, for example, does not only apply to the translucent patches themselves but more particularly to the manner in which they are linked together. That Galatea has a torso, hands, legs, and feet is not the only important fact; her position on the canvas with respect to that of the other objects is just as significant, as is the interrelationship of the individual components themselves.

In the same way the portrayal of the cyclops does not depend on the inclusion of a gigantic body, and of powerful arms and legs—indeed they do not actually appear in the painting. Moreau limits himself to a representation of the relationship of the face to the hand. The instinctive search which we make to discover the appropriate connection between one element and another and thus to establish, for example, that 'this hand and this face belong to this body' is interrupted; the way in which the pictorial elements are organized militates against any mere attempt to decide which elements belong to which body or object. Consequently the likelihood we have of being able to differentiate successfully one component from another is further reduced, so that the question may pose itself of whether the hand and face actually do belong together. Indeed is it not true that the hand has the significance of a torso, to which the face is merely appendaged? Is the cyclops' face situated within the grotto-like hollow or not? The female nude confirms that such questions are appropriate: the details of her sitting or lying position remain indeterminate and the body fails to disclose where it is actually sitting and resting and how it is supporting itself. We do not have enough visual information to explain how the crooked arm and the left leg slipped behind the right disappear, or what the extended arm rests upon. In Stuck's *Sensuality* (III. 58), the position of the figure and what it uses as a support are hard to make out; in Gauguin's *When Will You Marry?* (III. 14) the question as to how the partially hidden figure is sitting, remains unanswered; the naked girl in Puvis de Chavannes' *Hope* (III. 45) floats rather than sits. In Moreau's *Galatea* we only need take note of the direction in which the cyclops is looking and the expression on his face to substantiate the assumption that nude and face are to be seen in relation to each other.

In these paintings, then, the interest is not directed so much at figures, objects, and individual

elements but rather at the function they have within the whole network of components which go to make up any particular image. This persistent endeavour to underline relativity of position and correspondence between attributes, rather than the attributes themselves, is supported by an open, compositional procedure, possibly using fan-like figuration, and by the cultivation of an impression of instability with respect both to the material qualities of depicted objects and their position on the canvas. This emphasis placed on the interplay of elements, whether they be figures or objects, encourages, at the same time, their portrayal in terms of stance, bearing, gesture and facial expression; that is, a system of signs which is sufficiently conventional to be regarded as a language and which we are able to interpret accurately. Thus we can tell from the way a person stands and holds himself whether in one situation he feels threatened and whether in another he accepts something calmly. In 'Stylist Art', however, such signs are not used to express action but rather to stimulate the process of cross-reference.

Such compositional procedures are adopted by both Symbolism and Art Nouveau, although each movement used them differently and accorded them more or less significance depending on the painter and on the nature of the painting; but in the case of both movements they supply pictorial devices ideally suited to a visual representation in terms, for instance, of the echoes it finds throughout the whole canvas. Thus a new range of unexplored thematic possibilities is opened up: not only in the work of Moreau but also in Puvis de Chavannes and Denis we have the portrayal of release from tension, of passivity, of frailty, of listless procrastination, or fatalistic acquiescence to the inevitable. In Stuck appears the theme of sin and its power to seduce; in Strathmann and Lechter we have the treatment of religious subjects; the work of Rossetti, Mucha, Munch, and Segantini reflects a preoccupation with the themes of eternal youth, purity and unassailable virtue.

In the course of the development from Symbolism to Art Nouveau the emphasis on the interrelationship of elements within a network came more and more to the fore. This finally resulted in equal if not greater importance being accorded to the interplay of the parts of a picture and their components, rather than to the depicted objects themselves, as is the case for example in Strathmann's *Maria* (Ill. 57) and Klimt's *The Kiss* (Ill. 24). This explains the tendency which Art Nouveau paintings have of dissolving into an association of flat areas whose function is not representational but decorative.

An attempt to come to a conclusion as to the difference between the compositional procedures of Symbolism and Art Nouveau would read as follows: by means of fan-like figurations as well as vertical and horizontal arrangements of elements, and by means of emphasis being placed on the material qualities of objects, Symbolism deprives the picture of definition and of solidity; this in its turn creates the impression that elements are able to shift in relation to each other. Consequently the paintings have an odd appearance, in that the figures they portray do not seem to belong at all to the world. Art Nouveau, on the other hand, stresses the thematic potential of material qualities once they are divorced from any strictly representational function: it uses them to articulate curving lines whether they are intrinsic features of the figures and objects or whether they form part of the superimposed pattern; because all the pictorial elements are of equal functional importance and, being arranged in similar ways, appear therefore interchangeable, the final impression is one of preciosity. Both currents of 'Stylist Art', therefore, achieve in their own way a de-materialization and a de-individualization of the object. What is wealth of detail in Symbolism becomes a richness of decorative configuration in Art Nouveau. In the case of the latter movement visual resistance is produced by rhythmic intricacy of line, often given the appearance of organic growth; in the former, the process of observation is constantly stimulated by the wealth of pictorial elements whose diminutive size and lack of

definition only gradually permit the on-looker to differentiate between them. In Symbolism the preoccupation with correspondences of attributes and the interplay of relative positions favour a depiction which is ambiguous not only with respect to when and where, but also to the nature of the action. If this is so, then it is equally true to say that the best works of Art Nouveau succeed in resolving the distinction that formerly existed between a figure and its background, thus creating a unit which can have compositional repercussions throughout the picture. The consequence of this is that objects and figures which were formerly isolated from each other by virtue of their position to the front, middle or rear of the perspective plane, now mesh to form a decorative pattern—literally a pictorial 'configuration', or as Rilke put it, the 'Quintessence of Pure Interrelations'. This represents an important step forward towards a form of art which is entirely non-representational and therefore absolute.

1900—The intellectual environment, social conditions and contemporary attitudes towards art

The understanding we have gained from the description and analysis of works and compositional procedures should permit us now not only to observe the paintings of 'Stylist Art' with intelligent interest but also to make a careful and profitable study of them, deriving at the same time pleasure from both activities. If, however, we wish to judge the works produced at the turn of the century (or at any other time for that matter) we must say something about the intellectual background of the period which provided the necessary inspiration for experimentation in the arts and thus led to the breakthrough to new styles. Furthermore, we must give some consideration to the nature of the society, which not only gave birth to 'Stylist Art' but also provided it with suitable subject matter and patrons. Finally an attempt must be made to trace some aspects of the two later developments in pure and applied art which had 'Stylist Art' as their starting-point: the one led from Symbolism through Surrealism to the various offshoots of Fantastic Art; the other passed from Art Nouveau to the De Stijl movement in Holland, to the Bauhaus movement in Germany, and to Russian Constructivism.

Sufficient knowledge of the ideas which were current around 1900 (and of contemporary social conditions) is also desirable for a satisfactory understanding of the rôle of the observer vis-à-vis 'Stylist Art'. This does not imply, however, that for such art to run the course it did, specific social conditions were required and that, had these been different, Symbolism and Art Nouveau would have assumed other forms, if they had existed at all.

The sense of impending crisis and the struggles for reform

Any history of the second half of the 19th century must also be a history of increasing industrialization and all which that entails: new developments in technology, the growth of cities and conurbations, the emergence of factories and of industrial plants. It must be a history of the unforeseen advances made in the field of the natural sciences on the basis of observation and experiment. Even by 1850 F. G. Stephens, the English journalist and critic, was able to write that 'science has extended its scope so much that it now investigates and quantifies the whole of creation' (4). The theory of evolution of Charles Darwin, one of the 19th century's most significant contributions to intellectual history, was first set out in *The Origin of Species* which appeared in 1859 and developed the highly controversial theory that life was a fight for survival leading to a process of selection among living creatures. These developments, both social and intellectual, not only display signs of great mutual influence but are often so closely bound up with each other that their individual strands are difficult to isolate. Nevertheless they

constitute the breeding ground for an awareness of impending crisis which has come to be regarded as the most characteristic feature of the modern era.

Symbolism as a movement made its influence felt throughout contemporary thought as well as in literature. Not only Baudelaire and Mallarmé but also Stefan George, Maeterlinck, Wilde, Yeats, and the Pole Przyszenski were conscious that theirs was an age of crisis and, in seeking to express this awareness, they used notions of decadence and of living in a cultural impasse as frames of reference. Symbolism fed on this awareness to produce an outlook on life which, with its mixture of mysticism, irrationalism, and spiritualism, informed the whole of one's actions, and gave ample scope for indulgence in irony and melancholy.

The aestheticism predominating in the arts towards the end of the century was a naturalist one, and found its most complete expression in literature and in the plastic and graphic arts. It represented a logical extension of earlier realistic tendencies and the final culmination of a process whereby art had attained an even greater understanding of its own nature and function. It was against this that both Symbolism and Art Nouveau turned; the former represented a revolt against the naturalist aesthetics; the latter was a fundamental reappraisal of the rôle of art, both pure and applied: from now on a thorough transformation of man's whole environment would be affected by artistic means, beginning with the objects in everyday use.

Realist and naturalist currents in 19th-century painting had gained their sense of direction from the positivism of the natural sciences. John Constable (1776–1837), for example, considered his painting to be a kind of natural philosophy and regarded as experiments the individual applications of his theory. Artists who belonged to these schools aimed at representing what they could observe, point to, and touch—in short, the external world. For such painters accuracy of detail was of paramount importance. Consequently naturalism was not so much concerned with nature as with those branches of science which might influence the theory and the practice of art. Moreover, attempts were made to make scientific methods serve artistic purposes wherever it seemed appropriate and productive. Artists, in deciding that the real world provided the most suitable subjects, showed a marked preference for scenes and situations drawn from the world of work and recreation (e.g. Max Liebermann, 1847–1935: *Cobbler's Workshop*, 1881; A. v. Menzel, 1815–1905: *Iron-Rolling Mill*, 1875; W. Leibl, 1844–1900: *Women at Church*, 1882). These paintings depict familiar facets of the external world using typical compositional schemes and faithful reproduction of characteristic detail. Consequently, even the untrained observer has no difficulty in appreciating their contents.

Such an approach to art has not only affected the way in which naturalist paintings themselves are observed but has also had considerable influence on the way in which we have looked at art ever since. Because the observer is obliged to respond to a painting of the naturalist school in exactly the same way as if he were surveying some aspect of the external world such as a landscape, he is unable to involve himself directly in the work and wrestle with its significance. He is thus condemned to a state of passive receptivity in which his response to the painting takes the form of assent or disapproval.

Symbolism owed its origin to a large extent to the haunting sense of the apocalyptic which pervaded the spirit of the age. Those many new and original ideas concerning the arts which were the inspiration for Symbolism in literature are already in the writings of Baudelaire. His sonnet *Correspondances*, 1846, is regarded as the first Symbolist poem. As the title implies, the poem deals with the links which unite all things and which exist between the real world and the world of the spirit. The poet's task is to discover these links or *correspondances* and reveal them to the world. Reflections of this kind, directed not least against the predominantly scientific and rational outlook of the century, finally caused Baudelaire and the Symbolist poets such as Mallarmé and Verlaine, who followed in his footsteps, to turn away from everyday reality

and further intensify the cryptic and deliberately ambiguous elements in their work. Similar preoccupations in the graphic arts led the Symbolist painters, for example, to develop techniques which would enable them to give concrete expression to those invisible links which, according to their theories, existed between beings and things.

At the heart of Art Nouveau lay the mutual opposition between handicrafts and machine production. The first signs of this appeared in England, where ever since the middle of the 19th century industrialization had been making spectacular advances before finally spreading at a later date to the continent. This caused a far-reaching transformation of every sector of the manufacturing world, from the workshop right through to the factory, from the small scale business to the large scale concern, from handicrafts to industry. The artisan became entrepreneur and factory-owner. Morris, picking up where Ruskin had left off, realized that the two ways of manufacturing goods—either manually by artisans or en masse by machine—were mutually exclusive. But rather than consider the new and very real means of production, he turned away from the present to seek inspiration in the past. The result was the elaboration of a utopian vision which advocated a return to the workshop system of medieval artisans. What was most highly prized in the handicrafts was the scope they provided for self-expression and originality on the part of the craftsman, allowing both the design and the execution of a product to be done by one hand. Originality of conception and quality of finish were particularly sought after because it was precisely these considerations that industrial production overlooked. In order to put these ideals into practice, Morris founded, in conjunction with other artists, a number of handicraft workshops such as Morris, Marshall, Faulkner and Co. in 1861 and Kelmscott Press in 1890.

Ruskin's thought, however, and the ideas and aspirations of Morris, who held lectures from 1878 to 1894 on 'Socialism as seen through the eyes of an artist', only become comprehensible once the goals they were trying to achieve are taken into account. They were in revolt against the inferior quality, the stereotyped design and the superfluous luxury finish of goods mass-produced for everyday use. The nature of Morris' socialism becomes clear if we bear in mind his desire not only to create an art accessible to everyone but to reduce as much as possible the inequalities in living and working conditions as well as the exploitation of human beings.

These intensive efforts to revitalize applied art techniques, using as a model for inspiration the practices of medieval artisans and the theories which were associated with them, had two major consequences: the skilled craftsman was well aware of how the manufacture of a first class product depended on the use of high quality material, on the choice of an appropriate process, and last but not least, on due consideration of what purpose the finished article would serve. In the same way Symbolist and Art Nouveau contributions to the graphic arts display a positive obsession with the potential of each medium and the problems associated with it— the choice of materials, their appropriate methods of treatment, the range of compositional possibilities. It is an obsession which is still in evidence in Expressionism, Cubism, and later movements. Symbolist painters sought to give concrete expression to the invisible processes taking place within the human psyche. In order to do this, they adapted for their own use traditional techniques of representation which had proved themselves able to render the layout of elements on a canvas readily intelligible to an observer and at the same time to elicit from him the desired response. Art Nouveau on the other hand turned its attention more and more to the expressive possibilities inherent in the use of ornament for its own sake and consequently to experimentation with materials suited to this purpose. It also endeavoured to make art once more an integral and familiar part of our everyday environment by cross-fertilizing pure art techniques whose inspiration is primarily aesthetic, and applied art techniques which are born of functional considerations.

Since the struggles for reform derived their impetus from the belief that skilled craftsmanship

was a superior form of manufacture to mass-production, it is not surprising that their advocates should rebel against the academicism of art so fiercely that the effects of this rebellion are still apparent today. After all, the academic tendency in art had certainly favoured, even if it had not been solely responsible for, the gulf separating the artist from the skilled craftsman, a gulf that had been steadily widening ever since the Middle Ages.

A survey of theory and its practical application in the year 1893

Though the movements struggling for the reform of the applied arts in the England of 1883 were not a uniform body but rather a loose association, reflecting a variety of different approaches and individual experiments, a focus for their interests was provided by the Art and Crafts Society under its first president Walter Crane. Now in the 'nineties such societies emerged all over Europe. A brief chronological summary of events with references to the most important centres and groups of 'Stylist' artists must suffice here. However, in order to give some impression of the theories which were current during this period, in any particular year, and of their practical application, we shall present a brief survey of the principal events of 1893.

In London *The Studio* was founded, a magazine which dealt primarily with applied arts and crafts and was responsible for popularizing the work of Beardsley. The Society of the Twenty (Société des Vingt or Les Vingt) was disbanded. This society had been established by O. Maus in Brussels in 1884 and had not only taken the place of leading contemporary French artists, including both Neo-Impressionists and Symbolists, but had also made the works of the Pre-Raphaelites known on the continent. As soon as 1894, however, the same O. Maus founded as a substitute a new society called La Libre Esthétique which existed until the outbreak of the First World War. By this time it was mainly the applied arts that were in vogue. S. Bing, the German dealer in japonaiserie, organized an exhibition of Japanese art in the Durand-Ruel Gallery, which since the 'seventies had given most of its support to the Impressionists. The *Mercure de France* printed extracts from van Gogh's letters. Gauguin had his first exhibition at the Durand-Ruel gallery. The art dealer and publisher, A. Vollard, a promoter of new developments in the arts such as 'Stylist Art', Fauvism, and Cubism, opened the gallery which has since become famous. Bernard wrote in the *Revue Blanche* his famous article on Redon, then left France to spend the next ten years in Constantinople and Egypt. The Chicago World Fair took place. In New York, Louis Comfort Tiffany exhibited the first iridescent glass vases. At an exhibition in Chicago the glassware of the brothers Daum proved a success. Monet painted his pictures of cathedrals. Matisse became a pupil of Moreau (1895). Burne-Jones exhibited his painting *Perseus* at the Society of Independent Artists (Société des Artistes Indépendants), founded in Paris in 1884 by Seurat, Signac, and Redon among others. Denis painted *The Muses*, Munch *The Scream*, Stuck *Sensuality*, and Toorop *The Three Brides* (Ill. 62). Maillol founded in Banyuls-sur-Mer a studio devoted to embroidery. The first exhibition of the Munich Secession took place from which Corinth, Slevogt, Trübner, Heine, Behrens, Eckmann, and others then broke off to form the Free Society, a splinter group that sought above all to establish closer contact with progressive artists abroad. The sculptor, Adolf von Hildebrand, friend of the art expert Konrad Fiedler and of Hans von Marées, published his important essay *The Problem of Form in the Plastic and Graphic Arts*. The Viennese art historian Alois Riegel published a book entitled *Problems Relating to Style. A History of Ornamentation—Some Preliminary Observations*. In his book *Degeneracy* (a term of abuse much used by those opposed to modern art, especially in the National Socialist era) Max Nordau condemned all the more recent developments in painting, including not only Art Nouveau but also Naturalism and Symbolism, as the criminal products of insane minds. The fact that what we now know as 'Stylist Art' appeared under a variety of names in different European countries shows how much artistic

20

trends between 1890 and 1910 tended to be internationally based rather than confined to small areas, and of no movement is this more true than of Art Nouveau. The term Art Nouveau itself, for instance, obviously owed its origin to the gallery of the same name, which S. Bing opened in Paris in 1895. The German term Jugendstil was suggested by the name of the magazine *Jugend*, first published in Munich in 1896. In England the movement went under the name of Modern Style and in Italy it was called Stile Modernista.

The factors which in England acted as catalysts and which favoured, even if they did not actually initiate, reforms in pure and applied arts alike, had a decisive influence throughout this whole period. Amongst them, the work of Blake, of the Pre-Raphaelites, of Whistler, the theories of Ruskin which Morris developed and put into practice, the special liking for ornamental motifs of an organic nature, (such as those taken from the vegetable world), as well as for techniques employed in Japanese art and imitated, for example, in woodcuts and in japonaiserie.

Since new developments in transport greatly facilitated communications, exchanges of artists on an international level became more and more frequent. Journeys made for the purpose of gathering information became almost as important as the training in public academies and private schools of art, which was still regarded as indispensable. An example of contact on an international level was the artists' colony of Pont-Aven, where painters met from many European countries including Denmark, Holland, Poland, and Russia, and then returned home, bearing with them new ideas for dissemination among local artists. It was here that Bernard and Gauguin worked out the theoretical and practical aspects of their Synthetist conception of painting. This involved the use of simplified forms lacking for the most part not only modelling but also any elaboration of detail, which were either marked off from the rest or built up into larger units by means of sharp, clear outlines. Where this technique is pronounced, it is generally referred to as Cloisonnisme. Both painters were much admired by the Nabis (Nabi is Hebrew for prophet), a group of young artists—Sérusier, Denis, Ranson, and Vuillard among others—who had studied together at the Académie Julian, and who, after Sérusier's meeting with Gauguin at Pont-Aven in 1888, formed themselves into a loose association. They saw their own efforts to endow forms of artistic expression with new life confirmed by Gauguin's reflections on the decorative possibilities of the layout of pictorial elements on the canvas. This is an appropriate place to mention the beneficial influence of the Académie Julian which had been in existence since 1860 and had counted the Nabis, Matisse, Derain, Léger, Liebermann, and Corinth among its students at one time or another. In 1889 Nolde attended one of the art courses; at a later date, Marcel Duchamp was also one of its pupils.

'Stylist Art' as an enrichment of our everyday lives

London, Brussels, and Paris were in addition to Munich, Vienna, Darmstadt, and Berlin the most important centres of 'Stylist Art'. Most of the new developments emanating from these cities were the result of secessionist activity. At the opening exhibition of the Munich Secession in 1893—the first of the secessions in German-speaking territory—not only were works of Böcklin, Strathmann, Stuck and Thoma on display but also paintings of artists from abroad such as Crane, Millais, Segantini and C. Schwabe. We cannot really speak of Jugendstil in Munich as a stylistically unified variant of Art Nouveau, but rather as a number of related experiments by individual artists which have a common source of inspiration. 1897 was the year in which the Vienna Secession (Society of Austrian Artists) was founded; its president was Gustav Klimt whose influence determined the whole development of Art Nouveau in Vienna. The magazine *Ver Sacrum*, the mouthpiece of the Secession, appeared in 1898 and its publication continued until 1904. 1898 also saw the opening of the Vienna Secession building, which had been built by J. M. Olbrich. The close union of pure and applied art was demonstrated

by the founding of the Vienna Workshops in 1903. They continued in the spirit of the workshops which Morris had set up for the applied arts. Similar aims were pursued by the 'Deutsche Werkbund' which was established in Munich in 1912 and saw its task as the 'refinement of techniques used in industry'. The same is true of the Cracow Workshops founded in 1913 and the 'Lad' association in Warsaw which came into being in 1926.

The first President of the Berlin Secession founded in 1898 was Max Liebermann. In the same year he was nominated a member of the Academy of Arts. The Berlin Secession developed out of the group of the 'Eleven', and numbered Klinger, Liebermann, and Leistikow among its members. In 1892 it resisted an attempt by the Union of Berlin Artists to take it over, when at the latter's instigation, the two groups joined forces to exhibit works by Munch. Leistikow stood out in the role of organizer, and the first exhibition took place in 1899. By 1895 *Pan*, a magazine devoted to the cause of 'Stylist Art', had appeared in Berlin. In 1899 the Grand duke Ernst Ludwig of Hesse summoned to Darmstadt the artists Christiansen, Habich, Bosselt, Huber, Brück, and later also Olbrich and Behrens with the express purpose of raising the standard of applied art in both manual trades and industry. This led to the founding of the Darmstadt artist colony, whose most singular achievements were in the fields of architecture and handicrafts and whose contributions to painting were of less importance. In 1901 their first exhibition took place on the Mathildenhöhe. On display were architecture (most of the buildings were planned by Olbrich) and designs for the decoration of interiors. The exhibition was accompanied by the appearance of an imposing publication under the name of *A Document of German Art*. The great jubilee exhibition which opened in the Hessisches Landesmuseum in Darmstadt on October 22, 1976, included a comprehensive display of Secession and Avantgarde art around 1900, the work of Darmstadt artists between 1899 and 1914, as well as the literature and book illustration of Jugendstil.

The close collaboration of artists and writers was reflected in the founding of various magazines which not only stimulated the exchange of ideas among the members of individual groups but also promoted their dissemination among a wider public. In addition to being published in association with particular groups of artists and acting as their various mouthpieces, periodicals in general became a forum for the latest trends and ideas on the artistic scene. Between 1891 and 1903 there appeared in Paris *La Revue Blanche*, a magazine which was above all a rallying point for the younger representatives of Symbolism. It was here that Toulouse-Lautrec published his lithographs and the Nabis their woodcuts and other pieces of graphic art. Though *The Studio* was the magazine of the greatest importance in England, *The Yellow Book* was not without significance in the period from 1894 to 1897. Beardsley was for a year one of its principal collaborators. Between 1897 and 1934 *German Art and Decoration* was published in Darmstadt. 1899 was the first year in which the Berlin publication *The Island* appeared with the claim to be a rallying point for the most valuable productions of literature and book illustrations. All over Europe the publication of new art magazines and periodicals continued unabated; some only appeared for a short time, such as the Cracow *Zycie* that did not survive beyond 1899, the year of its first issue, or the *Mir Iskusstwa* which came out in 1899 but was only published for just over five years.

Artistic expression versus the technology of communications

Symbolism was born out of a popularized idealism which owed something to aspects of the so-called Romantic agony as well as to Eclecticism and Spiritualism. In the 'eighties and 'nineties it became a movement of international proportions which worked with the utmost persistence to produce an imaginary, often fanciful world, which was seen to be a counterpart of our own. In 1884 Joris Karl Huysmans published his novel *A Rebours* (*Against Nature*)

which depicted in a programmatic fashion the desire to live life *against the grain*. The Symbolist artist was quite clear in his own mind that any faithful reproduction of the visible world only furthered the cause of scientific rationalism. This claimed that the only true reality was an external one, whose existence could be verified by observation and experiment; its doctrine merely encouraged people to look at the world as they had always done oblivious of the poetry and mystery of the phenomena surrounding them. Albert Aurier, a critic working for the *Mercure de France*, summed up what Jean Moréas had said about the aims of Symbolist literature, and the challenges it must face, as follows:

'A work of art . . . must be:

1. Ideist, since its unique ideal is to express the Idea;
2. Symbolist, since it expresses this Idea by means of forms;
3. Synthetic, since it arranges these forms or signs according to a generally intelligible system;
4. Subjective, since the object is not considered as a thing in itself, but as a sign apprehended by the subject;
5. Decorative (which is the logical consequence), for painting as it was conceived by the Egyptians and by the Primitives was no more than a manifestation of art which was at once Subjective, Synthetic, Symbolist, and Ideist.' (5)

Art Nouveau on the other hand grew out of dissatisfaction with uninspired craftsmanship and the sub-standard products manufactured by industry. Mass-produced goods lacking any kind of individuality no longer permitted a personal response. Consequently Art Nouveau doctrine combined an attempt to affect reforms in the applied arts with reflections of a more political nature which were socially progressive in spirit. Expressions such as 'utility style', a coinage of the Austrian Wagner, or 'something without practical use can never be beautiful', or the phrase of the American Sullivan, 'form is subordinate to function', are characteristic of this aspect of 'Stylist Art'. The direct outcome of reflections on the possibilities of a functional integration of art into life was the growing conviction that art was the key to a much needed spiritual regeneration at every level. This new conviction, reflecting as it did the emergence of a new social order and the corresponding change in the way people thought and behaved, advocated 'the understanding of life in terms of itself' and the replacement of all that was mechanical by what was creative and vital. Hence the preoccupation of 'Stylist Art' with the concept of 'forces' and the attempt to depict these by means of organic forms used decoratively—in particular plant-like motifs—and of the darting and billowing flow of line unhindered in its movement.

Such new doctrines and trends ran counter to the desires and expectations of most people in society. And this was hardly surprising for what was being advocated was a rebellion against the academic art of the salon with its portraiture and genre-painting, its nude studies and realistically conceived historical painting. Such art could only satisfy a society which had an uncritical and, in its own eyes, progressive commitment to materialism and scientific rationalism. In order to strengthen its position, academic art sought in the latter half of the 19th century to extend the scope of its subject matter and its range of ideas by drawing on thematic material which was no longer European and historical—scenes from Ancient Rome, for example—but rather exotic and frequently Middle Eastern. It subscribed to an all-embracing eclecticism which was in evidence at the regularly held world fairs. Art historians, in processing all the secondary material relating to 'Stylist Art', have persistently ignored one factor which sheds light on the phenomenon as a whole. The emergence of Symbolism and Art Nouveau and their subsequent development from localized phenomena into movements of European significance was paralleled not only by the increased mechanization of production methods but also by the considerable advances made in transport and communications technology whose true significance can only be judged now in the light of recent achievements in space. These advances facilitated contact

between people over large distances, and naturally had their effect on the lives of artists, who, as has been pointed out, met more frequently both on a national and international level. The hitherto widespread refusal to acknowledge the special nature of the relationship between progress in technology and corresponding developments in 'Stylist Art' was most probably a consequence of the 19th-century cult of the individual genius. This cult exacerbated an already present tendency to regard pure art on the one hand and applied arts and technology on the other as two mutually opposed manifestations of human endeavour.

The combustion engine and electricity were to determine the nature of social intercourse, more and more as the century drew to its close. In 1878 the world's first four-stroke engine was presented to the public at the World Fair in Paris. By 1891 motor bikes were already being factory-produced. In 1867 W. Siemens delivered his lecture *On the transformation of energy into electrical current without the use of permanent magnets* to the Berlin Academy of Sciences and paved the way not only for the electric motor and for electric lighting but also for the technological advances which would revolutionize communications altogether.

Decisive discoveries were also made at this time in the field of acoustics. In 1876 Edison introduced his so-called *phonograph* to the world. In 1877 P. Reis relayed information by telephone to his newspaper in Boston and was the first reporter to do so. In the same year the Berlin suburbs of Rummelsberg and Friedrichsdorf were connected by 'telegraph line with telephone'. By 1902 there were about four million telephone connections over the whole earth.

Using a system of dot and dash signals in conjunction with electromagnetic waves Marconi was able in 1897 to cover the twelve kilometres separating his ship in the Gulf of Spezia from the mainland. This was the beginning of wireless transmission, or radio. If in the third and fourth decades of the 19th century Niepce and Daguerre had laid the foundations for the subsequent development of the camera, it was the Berlin engineer Nippkow who at the beginning of the 'eighties pioneered the basic research that led ultimately to the invention of television.

It was not only in the field of technology that this was an age of pioneers, of discovery and inventions. The arts, too, were the scene of an immense amount of activity. But in each case the history of the developments which preceded spectacular advances and the nature of the objectives that were being followed were very different. In the development, manufacture, and application of new means of transport and communication, man's actions began to be governed more and more by a spirit of rationalism which saw as its highest goal the resolution of those problems in life that could be dealt with practically. For the advances made in transport and communications technology were aimed primarily at getting people to work on time, at promoting and maintaining business connections, at facilitating the exchange of information. In themselves such achievements of the scientific imagination were remarkable by any standards and industrialization in the fullest sense of the word would have been unthinkable without them. And yet in terms of the aims which they set themselves, they contributed less to a more equal division of labour among men than to divisiveness, in that they promoted a one-sided development of man's capacities which would enable him to isolate and solve an increasing number of technological problems. Conversation was reduced to the mere exchange of news and information. Idle activities of the imagination such as dreaming, longing, or even phantasizing which are without any definable purpose and therefore fail to produce tangible results, were not encouraged. They therefore remained unexplored only to re-emerge at a later date as one of the central preoccupations in the psycho-analytical work of Sigmund Freud: 'Less and less is anything undertaken for its own sake. To set out on a walk which would lead one to the bank of a river or the top of a mountain would be contrary to reason and therefore idiotic, if we judged the activity in terms of its usefulness; for that would mean that we were expending our energy on some foolish and counter-productive pastime. Formalized reason will only concede

that an activity is reasonable if it serves some other purpose—it might be recreational or conducive to health, in which case it would help to restore one's energy.' (6)

'Stylist Art' was a way of counteracting this increasingly prevalent tendency to deny any place in men's lives to the exercise of phantasy or to the use of all one's senses in a full-bodied and imaginative response to the world. Art, which during the course of the 19th century freed itself more and more from the dictates of traditional aesthetics and the conception of beauty associated with it, turned its attention to the thematic possibilities offered by this neglected world of the imagination with its emphasis on the sensuous and mysterious aspects of life. Consequently the scientific advances and the rationalistic and materialist view of the world which they implied were seen as a threat to humanity. 'The French Symbolists had a special term which they used to express their love for things that had lost their objective meaning—the word was "spleen". The arbitrariness, "absurdity" and "perversity", of their choice of objects was a conscious challenge to utilitarianism, striking it in the face and revealing, as if by some silent gesture, the irrationality of its logic and its inability to meet human needs.' (7) Thus it was that 'Stylist Art' turned away, above all, from the tendencies inherent in a practically oriented rationalism and sought rather to extend man's ability to use his senses and imagination in a way that would enrich life. Symbolism, therefore, created works which were open-ended, that is, works which in the strictest sense of the word were not complete because they never ceased to take on new meanings. It created works of phantasy, which demanded an active response from an observer who was prepared to be involved in a process at once visual, imaginative and intellectual. Entirely appropriate in this connection are the words written by Rilke in his essay on the Worpswede artists, in particular Vogeler, when he said that their paintings told no stories, but rather encouraged the observer to look at what was in front of him and find one of his own. Once this is understood, the often repeated criticism of 'Symbolist Art', namely that its inspiration was perhaps too literary, can be seen to apply less to the paintings themselves than to the manner in which they should be viewed: the observer is not so much expected to have a purely visual response to the painting, but is rather required to piece together from the evidence available some not entirely obvious narrative.

Art Nouveau painting also demands an observer who is prepared to pass from a state of comparative disinterest to one of committed absorption. For it, too, creates works which serve a two-fold purpose: not only are they objects of beauty, having no other function than that of giving pleasure to the eye, they are also intended as decorative objects with which to beautify man's environment, both public and private, and thus avoid the atrophy of his spirit and his aesthetic sense. The decorative aspect of these paintings that is so much in evidence induces the observer to view what he sees as a carefully ordered sequence of visual events. As each event is studied and its significance successfully unravelled, the observer's pleasure increases.

When one considers that 'Stylist Art' at the turn of the century saw itself not so much as the theory and practice of some aesthetic outlook but rather as a way of life, then Nietzsche's *Against the art of art works* becomes, though it was not intended as such, an appropriate artistic programme. 'Art should first and foremost make life more beautiful, that is, it should help to make us more bearable and, wherever possible, more congenial to others: with this in mind, it restrains and keeps us in check, creating new forms of intercourse . . . Art should then conceal and give new meaning to all the ugliness of the painful, wretched and dreadful things in life which despite all our efforts break forth again and again in accordance with the origins of human nature. It should do this above all with respect to the passions, the fears and the agonies of the mind; and wherever ugliness is unavoidable, or cannot be rooted out, it should content itself with illuminating what is of significance there. In comparison with this great, indeed, immense task of art, so-called Real Art, the "art of art works", is only an appendage.' (8)

Notes to the introduction

(1) H. H. Hofstätter, *Symbolismus und die Kunst der Jahrhundertwende*, Cologne, 1965, p. 51

(2) H. Bauer, *Kunsthistorik. Eine Kritische Einführung in das Studium der Kunstgeschichte*, Munich, 1976, p. 11

(3) H. H. Hofstätter, *ibid.*, p. 47

(4) G. Metken, *Die Präraffaeliten. Ethischer Realismus und Elfenbeinturm im 19 Jahrhundert*, Cologne 1974, p. 118

(5) P. Jullian, *The Symbolists*, London & New York, 1974, footnote 33, p. 227

(6) M. Horkheimer, *Zur Kritik der instrumentellen Vernunft. Aus den Voträgen und Aufzeichnungen seit Kriegsende*, published by A. Schmidt, Frankfurt am Main, p. 45

(7) M. Horkheimer, *ibid.*, p. 46

(8) F. Nietzsche, *Werke in drei Bänden*, published by Karl Schlechta, 2nd edition, revised, Munich, 1960, vol. I, p. 804

Sources of quotations in the text accompanying the illustrations

L. Corinth, 'Carl Strathmann', in *Kunst und Künstler I* (1903) p. 255–63; reprinted in *Grotesker Jugendstil.* 'Carl Strathmann', exhibition catalogue, Rheinisches Landesmuseum Bonn 1976, pp.79–83

M. Denis, *Nouvelles Théories*, Paris, 1922

P. Gauguin, *Letters*, M. Malingue, Berlin, 1960

M. Hess, *Dokumente zum Verständnis der modernen Malerei*, Reinbeck bei Hamburg, 1956 (speech No. 19)

F. Hodler, *1853–1918*, exhibition catalogue of the Vienna Secession 1962–3

H. H. Hofstätter, *Geschichte der Europäiachen Jugendstilmalerei*, Cologne, 1963

M. Imdahl, *Marées, Fiedler, Hildebrand, Riegel, Cézanne.* Paintings and quotations in *Literatur und Gesellschaft.* Festgabe für Benno von Wiese, Bonn, 1963, pp. 142–95

P. Jullian, *The Symbolists*, London and New York, 1974

K. Lankheit, 'Die Wiederentdeckung Gustave Moreaus', in *Das Kunstwerk, XVIII*, 1964, vol. 4, pp. 29–30

C. A. Loosli, *Ferdinand Hodler, Leben, Werk und Nachlass*, 4 volumes, Bern, 1921–4, vol. 4

H. Matisse, *Farbe und Gleichnis.* Collected Works, published by P. Schifferli, Frankfurt am Main, 1960

M. Praz, *The Romantic Agony*, Oxford University Press, 1970

O. Redon, *Selbstgespräch. Tagebucher und Aufzeichnungen 1867–1915*, Munich, 1971 (Diaries and Sketches)

R. M. Rilke, *Worpswede*, Bielefeld-Leipzig, 1910

E. Schiele, *Schriften und Zeichnungen*, Innsbruck O. J.

G. Segantini, *Schriften und Briefe*, published by B. Zehder-Segantini, Leipzig, 1912

Symbolismus in Europa, exhibition catalogue of the Staatliche Kunsthalle, Baden-Baden, 1976

H. van de Velde, 'A chapter on the design and construction of modern furniture' in H. van de Velde, *Zum Neuen Stil*, published by H. Curjel, Munich, 1955, pp. 57–67

Suggestions for further reading

I. Cremona, *Die Zeit des Jugendstils*, Munich-Vienna, 1966

R. Hamann–J. Hermand, *Stilkunst um 1900*, Munich, 1975 (Epochen deutscher Kultur von 1870 bis zur Gegenwart, vol. 4)

W. Hofmann, *Von der Nachahmung bis zur Erfindung der Wirklichkeit. Die Schöpferische Befreiung der Kunst 1890–1917*, Cologne, 1965

H. H. Hofstätter, *Geschichteder europäischen Jugendstilmalerei*, Cologne, 1963, 1975

H. H. Hofstätter, *Symbolismus und die Kunst der Jahrhundertwende*, Cologne, 1965, 1975

Jugendstil, published by J. Hermand, Darmstadt, 1971 (Wege der Forschung, vol. 110)

Jugendstil. Der Weg ins 20 Jahrhundert, published by H. Seling, Munich, 1959

P. Jullian, *The Symbolists*, London and New York, 1974

L. Lucien-Smith, *Symbolist Art*, London and New York, 1972

S. T. Madson, *Art Nouveau*, translated by R. J. Christopherson, World University Library, WUL 015, London, 1967

H. R. Rookmakers, *Synthetist Art Theories*, Amsterdam, 1959

R. Schmutzler, *Art Nouveau*, London and New York, 1962

G. Selle, *Jugendstil und Kunstindustrie. Zur Ökonomie und Ästhetik des Kunster gewerbes c. 1900*, Ravensburg, 1974

Symbolismus in Europa, exhibition catalogue of the Staatliche Kunsthalle, Baden-Baden, 1976

Biographical notes on the artists whose works appear in the illustrated section

Beardsley, Aubrey

Born in 1872 in Brighton, he died in 1898 at Mentone. 1888: apprentice in architect's studio; 1889: first signs of illness, office worker in London. 1891–2: acquaintance with W. Morris; 1892: first commission for an illustration; from 1893 a member of the production team of *The Studio*, temporarily a newspaper illustrator on the *Pall Mall Gazette*.

Bernard, Émile

Born in 1868 in Lille, he died in 1941 in Paris. He studied art at the Atelier Cormon in Paris, friendship with L. Anquetin and Toulouse-Lautrec; 1886: expulsion from the Atelier Cormon and acquaintance with van Gogh and Gauguin, journey to Brittany; 1888: stay at Pont-Aven, work on theoretical writings; 1889: participation in the first Nabis exhibition at the Salon de la Rose + Croix; 1893: departure for a ten-year stay in Italy; 1905: founding of the magazine *Rénovation Esthétique*.

Blake, William

Born in 1757 in London, he died there in 1827. 1771: apprenticed to an engraver; 1778: membership of the Royal Academy. 1781: met J. Flaxman and H. Füssli; 1800–3: on the Sussex coast, literary activity; 1803: return to London, illustrations for his own poems, work on theoretical writings on art in the *Descriptive Catalogue*.

Böcklin, Arnold

Born in 1827 in Basle, he died in 1901 at San Domenico near Fiesole. 1841–7: studied at the Düsseldorf Academy, met A. Feuerbach. 1850–2: first stay in Rome; 1852 (autumn)–1857: second stay in Rome. 1858: moved to Munich, met F. v. Lenbach and Count Schack; 1860–2: teacher at the art school in Weimar, then divided his time between Rome, Basle, and Munich; 1874–7: in Florence, acquaintance with H. von Marées and A. von Hildebrand; 1885–93: in Zurich, friendship with Gottfried Keller; 1893: moved to San Domenico.

Bonnard, Pierre

Born in 1867 in Fontenay-aux-Roses (Seine), he died in 1947 at Le Cannet (Cannes). 1888: at Académie Julian in Paris, friendship with Sérusier, Vuillard, Denis; 1889: with the Nabis group; 1890–1: shared a studio with Vuillard and Denis; 1891: joined the Indépendants; 1893: work exhibited at the first Salon d'Automne; journeys to Holland, Italy, England, Spain; from 1940 onwards in Le Cannet.

Burne-Jones, Edward

Born in 1833 in Birmingham, he died in 1898 in London. 1852: studied theology at Oxford; 1853: met Morris and Rossetti; 1857: painted together with Rossetti the hall of the Oxford Union Debating Society; 1859, 1862, 1873: journeys to Italy. 1864: member of the Old Watercolour Society; after 1877 exhibitions in the Grosvenor Gallery in London; 1885: member of the Royal Academy; 1895: became a peer; 1891–6: illustrations for the Kelmscott Press.

Crane, Walter

Born in 1845 in Liverpool, he died in 1915 in London. Crane was taught painting by his father, the miniaturist Thomas Crane; 1862: exhibited for the first time in the Royal Academy; 1863: began the first of a long series of book illustrations; applied art designs for Morris & Co.; 1885: joins the Socialist League with Morris; from 1891 onwards book illustrations for the Kelmscott Press; writings on art; after 1828 regular participation in the exhibitions of the Paris Salons; 1898: head of the Royal College of Art in London.

Denis, Maurice

Born in 1870 in Granville (Manche), he died in 1943 at Saint-Germain-en-Laye (Paris). 1887: pupil at the Académie Julian; 1888: studied under Moreau at the Académie des Beaux-Arts; friendship with Bonnard, Ranson, and Sérusier. 1888: fellow-founder of the Nabis group; participation in exhibitions of the Nabis, of the Salon des Indépendants and from 1895 of the Société Nationale des Beaux-Arts. Contributed work to exhibitions in Brussels in 1894 (Les Vingt, La Libre Esthétique) and in Vienna in 1903 (sixteenth Secession exhibition); 1890: publication of *La Défense du Néo-Traditionne*; 1912: the appearance of his *Théories*; 1922: of the *Nouvelles Théories*.

Gallén-Kallela, Axel

Born in 1865 in Pori (Finland), he died in 1931 in Stockholm. 1888: studied at the art school of the Finnish Society of Art in Helsinki, from 1884

at the Académie Julian and the Atelier Cormon in Paris, acquaintance with the Nabis; from 1890 once more resident in Finland. 1893: met the writer A. Paul from Berlin, a friend of Munch; 1894: in Berlin where he shared an exhibition with Munch; 1895: in England where he studied applied art.

Gauguin, Paul

Born in 1848 in Paris, he died in 1903 at Atouana in the South Seas. 1871–82: a bank employee. From 1874 activity as a painter; 1883 gave up his job; 1886 first stay at Pont-Aven; 1887: journeys to Panama and Martinique; 1888: once more in Pont-Aven where he met Sérusier; meeting with van Gogh in Arles. 1891–3: in Tahiti; 1893: returned to France; resident in Paris and Brittany; 1895: a second stay in Tahiti; 1901: moves permanently to the Marquesas.

Gogh, Vincent van

Born in 1853 in Groot-Zundert (Nordbrabant), he died in 1890 at Auvers-sur-Oise. 1869–76: active as an art dealer, then as a teacher and priest; 1877–8: studied theology in Amsterdam; chaplaincy in Borinage; 1885: studied at the academy in Antwerp; 1886: moved to Arles; met Gauguin; deterioration of mental health. 1889: confined to an institution in St-Remis; 1890: moved to Auvers-sur-Oise.

Hodler, Fernand

Born in 1853 in Gürzelen (Canton Bern), he died in 1918 in Geneva. 1867: received his first lessons from S. Sommer in Thun; 1872: at the art school in Geneva; 1878: in Spain; from 1885 onwards friendship with the Symbolist poet L. Duchosal; 1891: in Paris. A member of the Société Nationale des Artistes Français; 1896–9: director of a course in drawing and painting in Fribourg; 1900: member of the Munich Secession; 1905: shared an exhibition in Berlin with Klimt, Klinger, von Hofmann. 1908: president of the Swiss Society of Painters, Sculptors and Architects; 1913: Officier de la Légion d'Honneur; 1916–17: director of the Cours Supérieur de Dessin at the school of art in Geneva.

Hofmann, Ludwig von

Born in 1861 in Darmstadt, he died in 1945 in Pillnitz. 1883–6: studied at academies in Dresden, Karlsruhe, Munich; 1889: studied at the Académie Julian in Paris; from 1890 in Berlin and a member of the 'Eleven' with L. Corinth, Klinger, Leistikow, and Liebermann. 1903: received an appointment at the school of art in Weimar; 1906: Greek tour with Hauptmann; 1916: teacher at the academy in Dresden.

Kandinsky, Wassily

Born in 1886 in Moscow, he died in 1944 at Neuilly-sur-Seine. 1886: studied law and political economy in Moscow; 1897–1900: studied at the Azbé School in Munich and at the Munich Academy under von Stuck; 1903–6: journeys to France, Italy, and Tunis; 1909: fellow founder of the New Society of Artists in Munich; 1911: founding of the Blaue Reiter; 1914: returned to Moscow, professor at the Academy of Art; 1921: returned to Germany; 1933: moved permanently to Neuilly-sur-Seine.

Khnopff, Fernand

Born in 1858 at Schloss Grembergen (West Flanders), he died in 1921 in Brussels. 1878: studied at the Academy in Brussels with Mellery; 1879: in Paris; member of the Brussels-based group of artists L'Essor and in 1884 a founding member of the Société des Vingt; friendship with Burne-Jones and the poet Verhaeren; 1892: participation in the first Salon de la Rose + Croix; 1894: a member of the Libre Esthétique; exhibitions with the Munich and Vienna Secessions.

Klimt, Gustav

Born in 1862 in Baumgarten (Vienna), he died in 1918 in Vienna. 1876–83: studied at the School of Applied Arts in Vienna; 1897: founder and president of the Vienna Secession; until 1905 organizer of the Secession exhibitions with O. Mall and J. Hofmann; 1898: honorary member of the international art committee in London; 1905: withdrawal from the Vienna Secession; received the Villa Romana prize; 1906: journeys to Brussels and London, in 1909 to Paris; from 1912: president of the Austrian Association of Artists.

Klinger, Max

Born in 1857 in Leipzig, he died in 1920 at Grossjena near Naumburg. 1874–6: studied at academies in Berlin and Karlsruhe together with M. Slevogt and Hodler; 1879: in the studio of C. C. Wouters in Brussels; 1883–6: in Paris; 1888–90: Italian journey, meeting with Böcklin; 1892: a member of the group of the 'Eleven'; 1897: professorship at the Academy of Graphic Arts in

Leipzig; from 1903 resident in Grossjena; 1905: founding of the 'Villa Romana' in Florence.

Kupka, František

Born in 1871 in Opočno (East Bohemia), he died in 1957 at Puteaux (France). 1889: studied at the Prague Academy; 1896: moved to Paris and met Mucha; 1899: cycles *Gold, Peace,* and *Religion*; from 1900 exhibitions in the Salon d'Automne and the Salon des Indépendants; 1910: publication of the *Technical Manifesto of Futurist Painting*; 1911: his first completely abstract painting *La Fugue en Rouge et Bleu*; 1931: founding of the Abstraction-Création group with van Doesburg, Herbin, Gleizes.

Lechter, Melchior

Born in 1865 in Münster (Westphalia), he died in 1937 in Raron (Wallis). 1895: studied at the academy in Berlin; 1895: friendship with Stefan George; beginning of his work for the *Journal for Art*; from 1897 book illustrations for the works of George, Wolfskehl, and Maeterlinck; 1898–1900: decoration of the Pallenberg room in the Cologne Museum of Applied Arts for which he received the 1900 Grand Prix in Paris; 1901: journey to Italy; exhibitions from 1901 onwards in the Keller and Reiner Gallery in Berlin. 1909: founding of the Acorn Press; 1911: journey to India; 1914–22: book illustrations for *The Four Books of The Imitation of Christ* by Thomas à Kempis.

Leistikow, Walter

Born in 1865 in Bromberg, he died in 1908 in Berlin. 1883: studied at the Berlin Academy; 1890–1900: teacher at the school of art in Berlin; friendship with G. Hauptmann; from 1892 onwards literary activity; 1896: publication of the novel *On the Brink*; designs for carpets, wallpaper, and furniture. 1892: fellow founder of the group of the 'Eleven' in Berlin; 1899 fellow founder of the Berlin Secession that developed out of the 'Eleven'; 1904: fellow founder of the German Association of Artists.

Mackintosh, Charles Rennie

Born in 1868 in Glasgow, he died in 1928 in London. 1885: studied at the art school in Glasgow and was employed by the building firm J. Honeyman & Keppie; 1904–13: director of the firm; from 1890 designs for furniture, chandeliers, etc. and for buildings. 1900: participated in the Vienna Secession; 1901: won the second prize in a competition organized by the Darmstadt *Magazine for Interior Decoration*; 1902: design and execution of the Scottish pavilion to be shown at the Turin Exhibition; after 1922 he devoted himself mainly to watercolours.

Maillol, Aristide

Born in 1861 at Banyuls-sur-Mer, where he died in 1944. 1885: studied at the École des Beaux-Arts in Paris; 1892 met Gauguin and the Nabis; 1893: opened a carpet factory in Banyuls; 1902: exhibition of eleven tapestries; met H. Graf Kessler; 1908: in Greece together with Graf Kessler and Hugo von Hofmannsthal; 1910–12: commission for a monument to Cézanne; work on numerous monuments and illustrations.

Marées, Hans von

Born in 1837 in Elberfeld, he died in 1887 in Rome. 1853–5: studied at the academy in Berlin with K. Steffeck; 1856–64: in Munich, friendship with F. von Lenbach; 1865–70: in Rome; 1869: journeys with K. Fiedler to Spain, France, and Holland; 1871–2: in Berlin with A. v. Hildebrand; 1872–3: in Dresden, 1873 in Naples, and subsequently mainly in Rome.

Matisse, Henri

Born in 1869 in Le Cateau (Northern France), he died in 1954 in Nice. 1887: studied law; from 1892 active as a painter; 1892: studied at Académie Julian and at École des Beaux-Arts in Paris; 1895–7: in Moreau's studio; 1905: he shared an exhibition with the Fauves in the Salon d'Automne; 1908: travelled to Germany; 1908–10: ran his own art school in Paris; 1910–13: visited Spain, Moscow, and Morocco; 1930: visited Tahiti and the United States.

Mehoffer, Jozef

Born in 1869 in Ropczyce in Poland, he died in 1946 in Cracow. 1887–9: studied at the academy of art in Cracow; 1889–90: studied at the Vienna Academy; 1891–6: studied at the Colarossi Academy and École Nationale des Beaux-Arts in Paris. 1896: return to Cracow; 1897: founder of the Society of Polish Artists (*Sztuka*), from 1902 professor at the academy of art in Cracow; 1894: won first prize in the competition for the glass windows of the Church of St. Nicholas in Fribourg, Switzerland; monumental

glass work in Polish churches; 1894–1936: windows for Cracow cathedral.

Millais, John Everett

Born in 1829 in Southampton, he died in 1896 in London. 1840: pupil at the Royal Academy in London; 1863: fully fledged member of the same institution and in 1896 its president; friendship with W. H. Hunt and Rossetti; 1848: fellow founder of the Pre-Raphaelite brotherhood.

Moreau, Gustave

Born in 1826 in Paris, where he died in 1898. 1846–9: studied at the École des Beaux-Arts; 1850–6: in the studio of Chasseriau; 1857–8: journey to Italy; 1852–67: participation in the exhibitions of the Paris salons; 1880: displayed his work for the last time in the salons; 1886: exhibition of his watercolour illustrations for the fables of La Fontaine; from 1892 professor at the École des Beaux-Arts where he taught, among others, H. Matisse and G. Rouault.

Morris, William

Born in 1834 in Walthamstow (Essex), he died in 1896 in London. 1853–5: studied theology at Exeter College, Oxford, together with Burne-Jones; 1856: moved to London with Burne-Jones; 1861: founded the firm Morris, Marshall, Faulkner and Co.; from 1875 continued management of the previous firm under the new name of Morris & Co.; 1877: founded a society for the protection of monuments; 1881: manufacture of his own designs at Merton Abbey in Southern England; 1883: became a member of the Socialist Democratic Federation; 1885: fellow founder of the Socialist League; 1890: founded the Kelmscott Press; appearance of his Utopian novel *News from Nowhere.*

Mucha, Alphons

Born in 1860 at Ivanice in Moravia, he died in 1939 in Prague. 1877: painter of stage-designs in Vienna, student at the academy in Munich; 1887: student at the Académie Julian in Paris; meeting with Huysmans and Maeterlinck; 1900: participation in the Paris World Fair where the expression *Style Mucha* was coined; 1904–11: resident in the USA; 1911: return to Prague; he later devoted himself to illustrations for the work of Merimée, Gautier, and others.

Munch, Edward

Born in 1863 in Loiten, Norway, he died in 1944 on his estate in Ekely near Oslo. 1885: first stay in Paris; 1892: exhibition of his early works in Berlin which caused a scandal; 1902: met Dr M. Linde, a patron of the arts from Lübeck; from 1909 resident in Norway.

Petrow-Wodkin, Kusma Sergejewitsch

Born in 1878 in Chawalynsk on the Volga, he died in 1939 in Leningrad. 1893–5: studied privately with Burow in Samara; 1897: at the Stieglitz School for Drawing and Applied Arts in St. Petersburg; 1897–1905: at the school for painting, sculpture, and architecture in Moscow; 1901: for a short period a student of the Azbé School in Munich; 1905–8: resident in Paris; 1908: returns to Leningrad where he joins the group Mir Isskusstwa; 1918–33: professor at the art academy in Leningrad.

Puvis de Chavannes, Pierre

Born in 1824 in Lyon, he died in 1898 in Paris. Pupil of H. Scheffer and T. Coutures; 1847: journey to Italy; 1851–2, 1859: exhibited in the salons in Paris; from 1861 commissions for murals; 1861–2: he painted the interior of the museum in Amiens; 1875–7 and 1897–8 painted the interior of the Panthéon, 1887–9 the interior of the Sorbonne, 1891–3 the interior of the Hôtel de Ville. 1890: fellow founder of the Société Nationale des Beaux-Arts in Paris and until 1891 its director.

Ranson, Paul

Born in 1864 in Limoges, he died in 1909 in Paris. Studied at the École des Arts Décoratifs in Limoges and Paris, 1888 at the Académie Julian; met Sérusier and the Nabis; shared exhibitions with the Nabis in the Salon des Indépendants as well as in the exhibition rooms of La Libre Esthétique in Brussels; 1908: he founded the Académie Ranson.

Redon, Odilon

Born in 1840 in Bordeaux, he died in 1916 in Paris. 1864: studied at the École des Beaux-Arts in Paris; 1870: permanent residence in the capital; 1884: president of the first Salon des Indépendants; 1887, 1884, and 1890: participation in the exhibition of the Société des Vingt in Brussels; 1894: exhibition at The Hague; 1903: exhibited with the Vienna Secession; 1895: stay in London; 1898: visited Amsterdam.

Rossetti, Dante Gabriel

Born in 1828 in London, he died in 1882 at Birchington-on-Sea. 1841: studied at Sass' School of Drawing; 1845–7: studied at the Royal Academy; 1848: founded the Pre-Raphaelite Brotherhood together with W. H. Hunt and J. E. Millais; 1849: visited Paris, Ghent, and Bruges with Hunt; 1856: at the centre of the Oxford circle that includes Morris and Burne-Jones; 1861: a founder member of Morris, Marshall, Faulkner & Co.; 1871–4: he rented, together with Morris, Kelmscott Manor in Gloucestershire; 1870 and 1881: appearance in print of his poems and translations.

Schiele, Egon

Born in 1890 at Tulln on the Danube, he died in 1918 in Vienna. 1906–7: studied at the Vienna Academy under Klimt; 1909: founding of the New Art Group; 1911: member of the artist group Sema; 1912: extensive travels; 1913: member of the Austrian Association of Artists; works on the production team of the Berlin magazine *Die Aktion*; frequent participation in exhibitions; 1915–6: military service; 1918: died of influenza three days after his wife.

Schmithals, Hans

Born in 1878 in Kreuznach, he died in 1964 in Munich. 1902: studied at the Obrist-Debschitz School for Applied Art in Munich; 1902–9: furniture designs; 1909 and 1911: time spent in Paris; 1912: founding of the Association of Interior Decorators together with W. von Wersin; 1913: exhibited his austere interiors in Munich, 1914 in Cologne, after 1920 in Berlin, Switzerland, and Munich; 1957–8: rediscovery of early works.

Segantini, Giovanni

Born in 1858 at Arco (Trentino), he died in 1899 at Schafberg (Salzkammergut). For a short period student at Brera Academy in Milan, but otherwise self-taught; 1886–94: experimented with pointilliste techniques; 1888–94: in Savognin and then in Maloja; 1898: publication of *What is Art?* in the magazine *Ver Sacrum*.

Sérusier, Paul

Born in 1865 in Paris, he died in 1927 in Morlaix. 1886: studied at the Académie Julian in Paris; 1888 met Gauguin in Pont-Aven; founding of the Nabis group; 1889–90: together with Gauguin in Brittany; in 1891 together with Verkade and Ballin in Huelgoat; 1895: travelled to Italy and to Prague; 1897 and 1899: stayed with Verkade in Beuron; from 1903 resident in Châteauneuf-du-Faou in Brittany; 1904: second journey to Italy; 1907: visited Stuttgart and Munich; 1908–12: a lecturer at the Académie Ranson; 1921: publication of *The ABC of Painting*.

Strathmann, Carl

Born in 1866 in Düsseldorf, he died in 1937 in Munich. 1882–6: studied at the Düsseldorf Academy; 1886–9: studied at the art school in Weimar; 1891: moved to Munich; 1893: participated for the first time in the exhibitions of the Munich Secession; 1894: member of the group of artists 'Independent Society' with Corinth, Behrens, Slevogt, and others; from 1896 works on *Pan*. 1900: a fellow founder of the German Workshops in Munich; 1907: a member of the German Association of Artists and the Berlin Secession.

Stuck, Franz von

Born in 1863 in Tettenweis (Lower Bavaria), he died in 1928 at Tetschen. 1882–4: studied at the School of Applied Arts in Munich and then at the Academy of Art; worked on the magazine *Jugend*; 1892: a fellow founder of the Munich Secession together with Trübner and others; 1895: a lecturer at the Academy in Munich; 1898: completion of the Villa Stuck; 1906: ennobled.

Thorn Prikker, Johan

Born in 1868 in The Hague, he died in 1932 in Cologne. 1883–7: student at the Academy in The Hague; associated with Les Vingt and friendship with van de Velde; 1892–5: painted works of a predominantly religious nature; 1892–5: correspondence with the writer H. Borel; 1904: lecturer at the School of Applied Arts in Krefeld; 1910–19: lecturer at the Folkwang School in Hagen; 1919–23: at the School of Applied Arts in Munich; 1923–32: professor at the Cologne School of Applied Arts.

Toorop, Jan

Born in 1858 in Poerworedjo (Java), he died in 1928 in The Hague. From 1869 in Holland; 1880–1: studied at the Academy in Amsterdam; 1882–5: studied at the Academy in Brussels; from 1886 member of Les Vingt; 1891: resident in The Hague and a member of the local com-

munity of artists; 1891, 1899, and 1902: periods of residence in Kwarijk, 1903–9 in Amsterdam; 1905: adoption of Catholic faith; 1908: participated in the St. Luke Exhibition in Amsterdam; 1916: returned to The Hague.

Toulouse-Lautrec, Henri de

Born in 1864 at Albi, he died in 1901 in Malromé. 1878 and 1879: accidents in which he was permanently crippled. 1882: in the Princeteau studio in Paris, short time in the Bonnat studio; 1883: in the Atelier Cormon; met van Gogh, Anquetin, Bernard; 1887: established his own studio in Montmartre; 1895: brief acquaintance with Oscar Wilde; 1899: entered a clinic for nervous diseases where he stays until the end of the year; 1901: arranged the paintings in his studio and travelled to Arcachon; complete paralysis set in.

Vallotton, Felix

Born in 1865 in Lausanne, he died in 1925 in Paris. 1882–5: studied at the Académie des Beaux-Arts in Antwerp; 1884–5: residence in Paris; 1888: member of Les Vingt; 1900–14: residence in Germany, and from 1902 director of the School for Applied Arts in Weimar; 1907: publication of *Concerning the New Style*; 1925: became director of the Institut Supérieur des Arts Décoratifs in Brussels that had been specially founded for him.

Velde, Henry van de

Born in 1863 in Antwerp, he died in 1957 in Zurich. 1882–4: studied at the Académie des Beaux-Arts in Antwerp; 1884–5: stay in Paris; 1888: member of the artist group Les Vingt; 1900–14: residence in Germany; in 1902 he became the director of the School of Applied Arts in Weimar; in the same year he published the *Readings in Applied Art for the Layman*. 1907: publication of his *On the New Style*; 1925: became director of the Institut Supérieur des Art Décoratifs in Brussels.

Vogeler, Heinrich

Born in 1872 in Bremen, he died in 1942 in Kasachstan. 1890–3: studied at the Academy in Düsseldorf; 1891: travelled to Holland and Italy, and in 1894 to Paris; pupil of Mackenson and H. am Ende in Worpswede. 1898: visited Florence; 1899: publication of a volume of poems entitled *For You*; 1901: visited Amsterdam, Paris, Bruges; 1903: visited Lodz; 1908: founding of the Worpswede Workshops for Farmhouse Furniture; 1913: separation from his family, and subsequent turning to Socialism; 1932: moved to Russia, gave lectures on art education in Moscow.

Vuillard, Édouard

Born in 1868 in Cuiseaux (Saone-et-Loire), he died in 1940 in La Baule. From 1877 resident in Paris where he studied at the Académie Maillart; from 1888 at the Académie Julian and at the Académie des Beaux-Arts; friendship with the Nabis, especially Denis and Bonnard; 1890–5: participation in the exhibitions at Le Barc de Bouteville; 1908: teacher at the Académie Ranson; 1913: stayed in Holland and England, and in 1939 in Geneva.

Watts, George Frederick

Born in 1817 in London, he died there in 1904. 1835–42: studied at the Royal Academy; 1843: won first prize in the competition for the painting of the interior of Westminster Hall; 1843: stayed in Italy; 1847: began a series of monumental works; 1867: member of the Royal Academy; 1902: received the Order of Merit.

Whistler, James Abbot McNeill

Born in 1834 in Lowell (Mass., USA), he died in 1903 in London. 1843–9: studied drawing at the Imperial Academy in St. Petersburg; 1849: returned to the USA; from 1855 received tuition in Paris from Gleyre; 1858: founding of the Société des Trois with Fantin-Latour and Legros. From 1859 spent most of his time in London where he met the Pre-Raphaelites; 1864 and 1865: visited Courbet; from 1870 devoted himself almost exclusively to portraiture; from 1888 friendship with Mallarmé; 1890: appearance of his autobiography *The Gentle Art of Making Enemies*.

Wrubel, Michael Alexandrowitsch

Born in 1856 in Omsk (Siberia), he died in 1910 in St. Petersburg. He began by studying Law in St. Petersburg but changed to art; from 1880 studied at the Academy in St. Petersburg; 1884–5: visited Italy; 1889: moved to Moscow where he met Nesterow, Korowin, and Serow; 1906: participated in exhibitions in Paris and Berlin, and in 1907 in Venice; 1902: affected by an incurable disease, later entered an institution.

The works of **Beardsley**, published separately and scattered throughout a variety of magazines such as the *Island*, the *Amethyst*, the *Hyperion* or the *Opal*, created a sensation; his illustrations for Oscar Wilde's *Salome* (1896), or Alexander Pope's *Rape of the Lock* (1896–7), and his posthumously-published drawings for Ben Jonson's *Volpone* (1896), also appeared in book form, although his arrestingly bold illustrations for Aristophanes' *Lysistrata*, which circulated in the circles of German admirers, were banned in England on account of their satirical and erotic content.

A whole generation of gifted artists, including stage designers, succumbed to his powerful influence. Beardsley especially admired Wilde and took at its face value his aphorism that 'Virtue and vice are the artist's raw materials'. Impressed by Wilde's writing, he valued it in particular for its dazzling effects. He attempted to realize Wilde's aesthetics in a form that was valid for the graphic arts using such means as line, definition, contour, and flat surfaces.

We find the legend of Saint Rosa of Lima in the fragment of a novella entitled *Beneath the Hill. A Romantic Tale*: '. . . Saint Rosa, the famous Peruvian virgin; how she vowed ever to remain a virgin, when she was only four years old . . . and after going to the top of a little hill not far beyond the walls of Lima on the morning of her wedding, how she knelt there and gently called on the name of Our Lady, and how Holy Mary came down and kissed Rosa on the forehead and quickly carried her up into heaven.'

The version that Beardsley drew of the legend of Isolde speaks for itself. Isolde, in the belief that she is drinking a death potion, drinks a love potion by mistake. Significantly, the artist interests himself in the female figure alone. What we see, then, is simply a woman dressed in rich clothes, placing a goblet to her mouth. It is only through the inscription that the theme becomes identifiable.

No attempt is made in these paintings to reproduce the human anatomy in all its complex detail. Nor is the drawing of the figures correct in any realistic sense. On the contrary the anatomical details that we do have such as hands, feet, and face, seem to be there simply to help us to orient ourselves. The overriding impression is one of interplay of line and flat surfaces. In terms of realistic drawing techniques this procedure may well appear faulty, but in its refined form, it becomes the structural basis of Beardsley's work. He

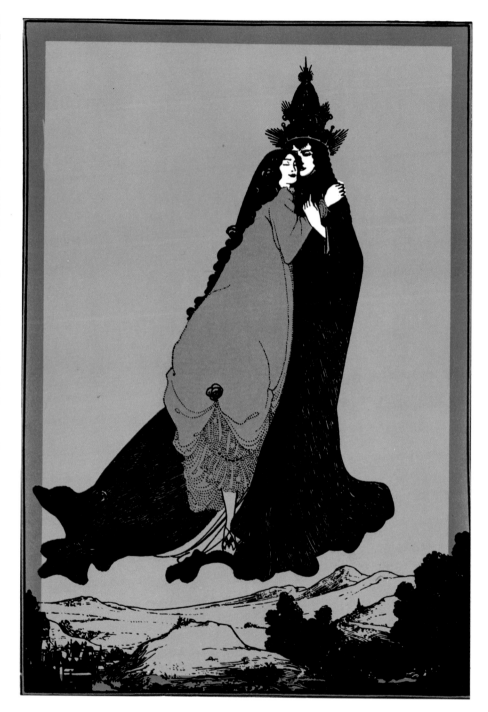

1 Aubrey Beardsley
The Ascension of St. Rosa of Lima, **1896**
Colour lithograph. 23,1 × **16 cm**

2 Aubrey Beardsley
Isolde, c. **1895**
Colour lithograph. 24.8 × 15 cm
From *The Studio,* **London 1896**

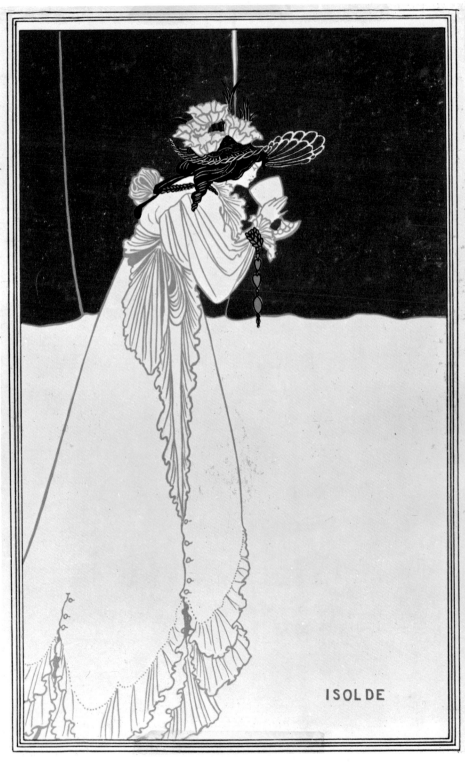

ISOLDE

takes great pains to avoid any impression of the line being the product of spontaneous and inspired feeling. To do this, he gives the thin strips of colour, the lines and bundles of lines, the appearance of wire. Moreover, the lines which run parallel with the frame are highly reminiscent of technical drawing; they have an unusually sharp edge and are symmetrically arranged. Beardsley was not the first to experiment with such features, however, for we find them already in the work of William Blake (Ill. 4).

The lines within the bodies themselves often become so fine that they take on a hair-like appearance. Not only do they dictate the position and boundary of each division of the flat surface but they also determine drapery and costume. As each figure is drawn, all incidental characteristics such as facial features and clothing are more or less ignored. What results is the painting of an archetype lacking the attributes of the individual, as though a number of figures had been drawn one on top of the other. Surfaces bounded by lines, by flourishes and by the proliferation of rows of dots, necklace-like in appearance, are used to depict archetypal kinds of movement, stance and scenario. The final impression is of decorative stylisation, in which contrast is not only between vertical and horizontal alignment but also between empty space and richly detailed sections, within the overall context of extended full-length formats. Despite his use of long lines, whose sensuous, fluid, yet rhythmic configurations might be said to resemble music, or some exotic script, the artist does not completely divorce the non-imitative and undifferentiated ornamental work from what is essentially a piece of concrete representation. On the contrary, it is precisely the way in which Beardsley dresses his figures that reveals what his artistic intentions are. Far from designing costume arrangements that bear no relation to the human anatomy, he causes the attire of his figures to hang in such a way that certain parts of the body are particularly emphasized. Depending on the attitude of the observer in question, the figure could be regarded as richly draped and therefore embellished, or as flagrantly unclad.

3 Émile Bernard
Madeleine in the 'Bois d'Amour'
1888
Oil on canvas
138 × 163 cm
Paris
C. Altarriba
Collection

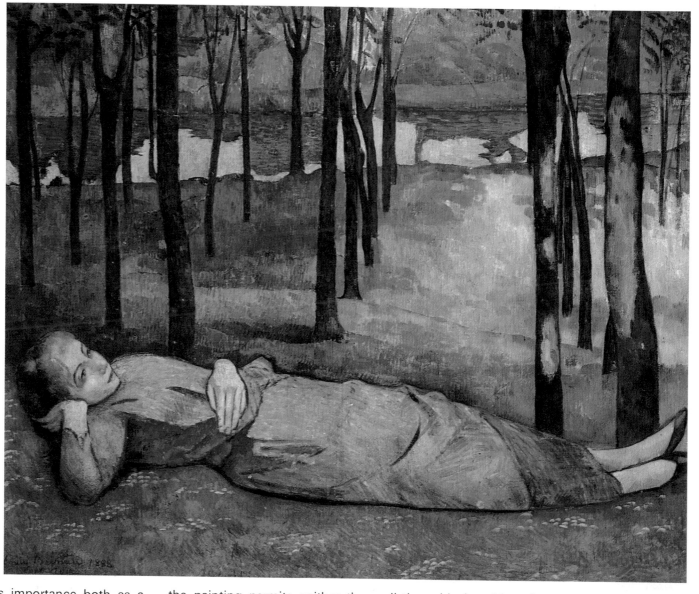

In the light of his importance both as a theoretician and as a practising artist in his own right, Émile **Bernard** can without doubt be regarded as the head of the group of artists resident in the Breton village of Pont-Aven. It was to this group that Gauguin (Ills. 14-16), C. Filiger, C. Laval, L. Anquetin, P. Seguin and P. Sérusier (Ills. 55, 56) belonged for different lengths of time. Bernard's paintings must be regarded along with those of Gauguin as some of the finest works produced by Symbolism.

Our illustration shows the artist's sister; the large and small scale articulation of the painting permits neither the realistic representation of illusionistic space nor the modelling of objects in three dimensions. The whole surface is divided into flat, horizontal zones which are placed one on top of the other and correspond in the main with the edge of the forest, then the figure reclining along the whole length of the canvas, then a section of the forest with tree trunks, a narrow stretch of water and an area of foliage. Moreover, within these flat and stratified divisions there are sizeable areas of undiluted colour that acquire shape and definition through their heavy contours. These contours, generally black or blue, determine the composition of the whole painting. It was this device that formed the basis of Cloisonnisme, a technique which Bernard developed with Anquetin in 1887 and which Gauguin then adopted and made famous.

It was Moreau who had introduced an associative compositional technique in which the relations between pictorial elements were more important than what they actually depicted. Bernard, in founding the Pont-Aven style, was to develop his own version, which then became the basis of all his paintings.

35

**4 William Blake
Illustration for the allegorical poem**
The Four Zoas
**Pen and watercolour
Private Collection**

Johann Heinrich Füssli (1741–1825). The former was not only an illustrator and painter, but also a poet, mystic and visionary; the latter was a Swiss painter who settled in England in 1764.

In deliberately choosing one of Blake's works with a conventional theme, we have sought to underline the revolutionary nature of its conception and thus show why it is that he can be regarded as a forerunner of Symbolism. No longer content merely to represent aspects of the real world or scenes from some mythological or fictional counterpart, he strives to render in visual terms the invisible and intangible world of the soul. In order to do this he rejects, or rather transforms, such devices of pictorial organization which had hitherto satisfied the needs of a more realistic view of the external world. For Blake the act of perception which enlisted the aid of the senses had lost its traditional supremacy.

He abandoned realism and any attempt to beautify what he portrayed by the addition of realistic detail; colour was for him neither a means with which to effect the ideal representation of what he saw nor a way of giving the eye sensual delight. The result of this was a practical method of composition that permitted him to create a pictorial conception unified in terms of itself but no longer corresponding to the 'truth of nature'.

Characteristic of his work is the division of the canvas into spatial units which lack perspective and thus create the impression that the location of the objects in the painting as well as their physical boundaries are indeterminate. The familiar illusion of a physical reality, in which beings are able to live and move and things have their place, is abandoned. Instead we have an assembly of three-dimensional spaces whose function is entirely subordinated to the conception of the painting; they cannot be equated with anything outside themselves. Consequently the artist is able to distort both the anatomy and physiognomy of his figures in order to represent some spiritual state.

Ever since the middle of the 18th century man had become increasingly aware of the irrational forces which he recognized to form an intrinsic part of his make-up. The Enlightenment with its humane ideals realized that rational thought alone could not provide the key to the mysteries of creation or enable man to progress. Moreover, human nature was seen not only in the context of rational motivation but also of experience, feeling and action. Such new insights expressed themselves in a radical change of sensibility. The two artists with the greatest claim to be regarded, in the light of their work, as the forerunners of Symbolist Art are **Blake** and

36

The reception accorded to **Böcklin**'s paintings by the public, not only at the time of their execution, but also after his death, was typical of the general reception accorded to 'Stylist Art'. This artist, whose aim it was 'to embrace and express the essence of several arts' (Richard Huch), established that line of development which (leaving out for the moment Cézanne and the French Impressionists) led from late Romanticism through Symbolism and Art Nouveau to 20th-century Surrealism. The poetic, musical, and painterly aspects of Böcklin's work are ample proof of its tendency to transcend the various forms of artistic expression. In Hoffmannsthal's *Idyll* (1893) the stage directions begin '. . . the scene in the style of Böcklin'. In Rilke's *The White Princess*

(1898) the scene is Böcklin's *Villa by the Sea* (1878); in 1899 Nolde, the Expressionist, did his *Böcklin Studies* which still survive; in 1913 Reger composed his *Böcklin Suite.*

His principal themes, painted mostly in the studio, are villas and temples, the sea and its fantastic or mythological inhabitants, ruins with cypresses and black birds, figures with faces expressing joy and sadness beneath slender birches and poplars, self-portraits, often filled with symbolic motifs, pictures composed of familiar themes from literature, art and everyday life in free association. What were originally small-scale figures inhabiting antique landscapes become independent entities, frequently of monumental stature. They seemed most able to grant

release 'from the dull earth' (Böcklin) by presenting themselves as Greek gods, nymphs, Pans, fauns, tritons, and centaurs, which impersonated the forces operating on man and nature alike.

But Böcklin did not only help to popularize themes taken from the fictional world of fairy-tale and mythology, he was also a pioneer of painting techniques and was in part responsible for 20th-century advances in colour application.

Turning our attention now to two famous examples of Böcklin's work, which

5 Arnold Böcklin
The Island of the Dead, **1880**
Tempera on canvas. 111 × 155 cm
Basle, Kuntsmuseum

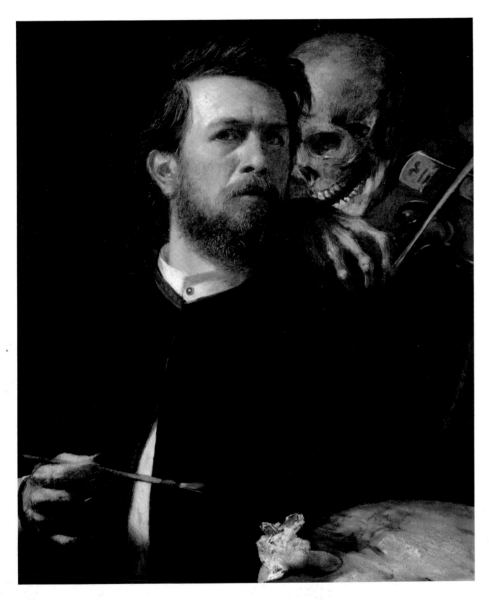

6 Arnold Böcklin
Self-Portrait with Death playing the Violin
1872. Oil on canvas. 75 × 61 cm
Staatlicher Museen Preussischer
Kulturbesitz

received both ecstatic acclaim and vigorous denunciation from the critics, *The Island of the Dead* and *Self-Portrait with Death playing the Violin*, we might come to the following conclusions: colour is of great significance with respect both to choice of colouring material (pigment, binding agent) as well as to the way in which it is employed in the overall layout

of the work. It is used to determine the basic mood of the painting whether it be one of serene dignity, elegiac melancholy, or funereal gloom. The painter tries to avoid giving any indication of contour or boundary to the colour areas; in the same way he consistently avoids any sign of visible brushwork. Böcklin makes particular use of grey, blue, and brown (earth) hues, each carefully simulated by the prior preparation on the palette of the necessary basic colours. The distribution of elements over the surface is not based on some geometrical scheme but is determined by the strategic positioning, in groups of three

for example, of focal points of light and colour. In the *Self-Portrait*, the focal points are represented by the following features: in the bottom left hand corner the hand and the paint brush that are intersected by the vertical boundary of the frame; in the bottom right hand corner, the palette and the rag that are intersected by the horizontal boundary of the frame; in the upper part of the canvas the artist's face, presented to us in three-quarter profile; then the skull, partially obscured by the face; and finally the skeleton's hand drawing its bow across a single-stringed violin, whose imaginary completion extends beyond the right hand boundary of the frame. *The Island of the Dead* shows the same technique: reading from left to right we have, amid the more brightly lit portions of the rock, some kind of architectural structure, coloured in a luminous yellow; in the middle an upright figure in a boat, and then again another luminous zone of rock. As is quite evident from the coloration of the focal points, the artist is not content to apply realistic colour schemes, he is more concerned to experiment with original colour combinations; a dominant pattern is the contrast between cold and warm hues. Because there is no longer a one-to-one correspondence between an object and the colour traditionally associated with it, the elements on the canvas seem to float, deprived of their substance. The ashen or dark grey hues of the cypresses in the centre shade off to form the darkest parts of the painting, while the brown coloration of the rocks is transformed into the luminous yellows of the buildings and the central, shrouded figure. Consequently it is to colour that we turn in order to make associations between apparently unconnected objects. And because the artist declines to make these associations explicit, whatever sense we make of the painting often depends on the highly subjective choices we have made. That it was Böcklin's intention that his painting be approached in this way is evident from the title which he himself originally gave it, namely *A Painting to Dream On*. 38

Bonnard was one of the co-founders of the Symbolist group of artists, the Nabis. Though his choice of theme and the manner in which he treats it betray the Impressionist origins of his works, he was, as a lithographer and furniture designer, closely associated with the efforts of the *Revue Blanche* to promote a new kind of decorative art (Art Nouveau). Because of their preference for tranquil scenes set in the home or garden, both he and Vuillard earned the name of 'Intimistes'. Bonnard combines an emphasis on the two-dimensional quality of his picture with the portrayal of an imagined observer briefly savouring some intimate scene. His palette, though at first subdued, developed a festive and decorative colourfulness.

7 P. Bonnard
Nude in Lamplight,
c. 1912.
Oil on canvas
75 × 75 cm
Berne
H. R. Hahnloser Collection

39

Burne-Jones, whose works were as much in demand on the continent as they were in England, drew upon allegory, mythology, and religion to create paintings, sketches, woodcuts intended for book illustrations, and cyclic works revolving round one particular character or sequence of incidents. The painting reproduced here belongs to the Perseus cycle, a commission begun in 1875. Its theme runs as follows: Perseus finds Medusa, decapitates her and shows the severed head to Atlas, who bears the world on his shoulders. By thus turning him to stone, Perseus punishes Atlas for having refused him hospitality. It is characteristic of Burne-Jones that, instead of depicting the climax of the action—the point at which Perseus holds out the Medusa's head to Atlas—he should choose to depict the state of affairs after the main event is over. For this allows him to isolate the slender, clearly defined frontal view of Atlas, whose statuesque linearity culminates in the gentle upwards movement of the outstretched arms. Associated with this stance, reminiscent of a dumb-show, is the gentle inclination of the head which is presented in three-quarter profile, the expressive rather than strained position of the hands, the placing of the feet, whose detailed articulation is more important than their function.

The frontal view of the naked Atlas is complemented by the rear view of the winged and armoured Perseus. Both figures represent emphatic vertical divisions of the surface which are echoed, more and more faintly as the background recedes, by sweeping diagonal and horizontal lines. The atmospheric graduations of the blue (that is the painting's principal colour and one which was much favoured by the artist in other works) have little to do with any realistic colour scheme. The compositional use of visual resistance means that the subject-matter is used as a pretext for very finely wrought surplus visual detail which has no thematic significance.

8 Edward Burne-Jones *Atlas is turned to Stone* **undated Tempera on canvas 152 × 191 cm Southampton Art Gallery** 40

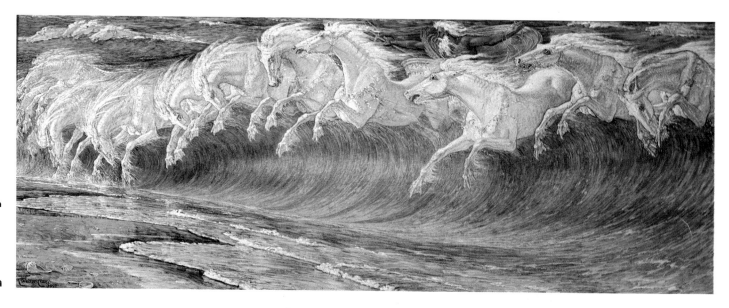

9
Walter
Crane
*The Horses
of Neptune*
1892
Oil on
canvas
86 × 215 cm
Munich
Bayerische
Staats-
gemäldes-
ammlungen

Crane like Kandinsky (Ill. 21) can be counted among those artists who made important theoretical contributions. A later follower of the Pre-Raphaelites, he also played a part in the reform of the applied arts. His books, in particular *The Rudiments of Drawing* (1898) and *Line and Form* (1900), testify to a wide knowledge of materials and their uses, clarity of thought, and didactic flair.

In his *Horses of Neptune* the whole canvas is dominated, from one end of the unusually slender horizontal format to the other, by the broad diagonal of the wave. As it turns, its crests are transformed into huge white horses with fins, except in the top left-hand corner of the painting where the distinction between horses' heads and foam is no longer visually significant.

The painting is a synthesis of Art Nouveau and Symbolist features. An association of the most disparate elements is articulated not only by the supremacy of line but also by the indissoluble union of line and form. If line were removed, then the figures would cease to exist.

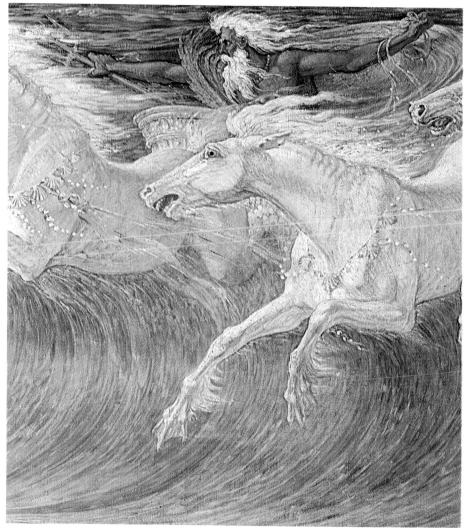

41 9a Detail of Ill. 9

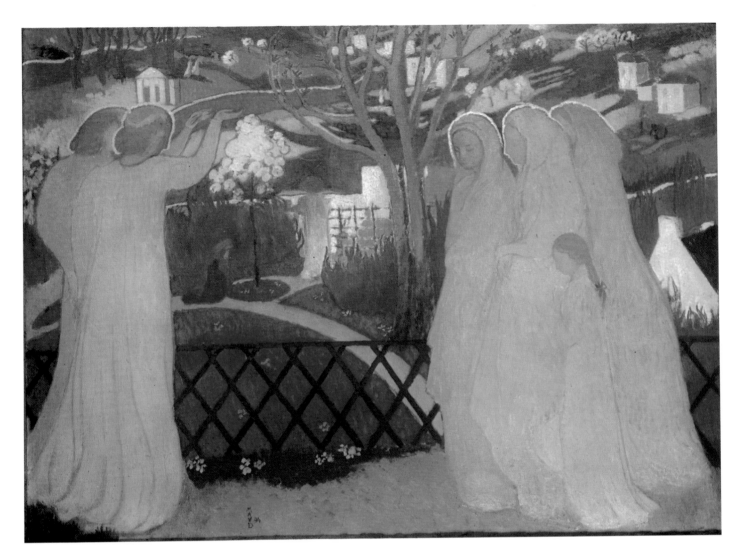

10 Maurice Denis
The Holy Women at the Tomb, **1894**
Oil on canvas. 74 × 100 cm
St. Germain-en-Laye
Private Collection

Crane's theoretical work dealt with problems whose resolution was of interest to all artists, whatever their aesthetic standpoint. **Denis** on the other hand, whose prime concern was to establish a theoretical framework that would help artists to give pictorial expression to an idea, played an important part in the formation of French Symbolist doctrine. Together with Sérusier (Ills. 55, 56), Bonnard (Ill. 7), Ranson (Ill. 47), Vuillard (Ill. 70), and Vallotton, with whom he studied for a time

at the Académie Julian, he was the founder member of the Nabis circle. He was active as a painter, in particular of biblical themes, as an applied artist, as a book illustrator (he drew illustrations for the works of Gide and Verlaine) and as a theatre and interior designer.

The painting *The Holy Women at the Tomb,* a typical product of Nabi Symbolism, achieves its effect from the close relationship between colour and surface. Though we have no difficulty in recognizing the objects depicted for what they are, it is not clear whether they are there to throw into relief a richly decorative combination of variously coloured surfaces, or, alternatively, whether these surface

divisions are intended not only to generate visual resonance but also to mesh and form a fence, clusters of trees, isolated buildings, and the figure of the risen Christ near the centre of the picture. This double function is achieved firstly by imparting to the objects an appearance of insolidity which deprives the canvas of spatial depth, and secondly by the omission of characteristic detail. For example, the female figures on the right and the angels on the left have more in common than their lack of joints or limbs, or their similar outline; the fact that they are all noticeably alike in the face and furthermore resemble each other in terms of stance, clothing and colouring, means that both

42

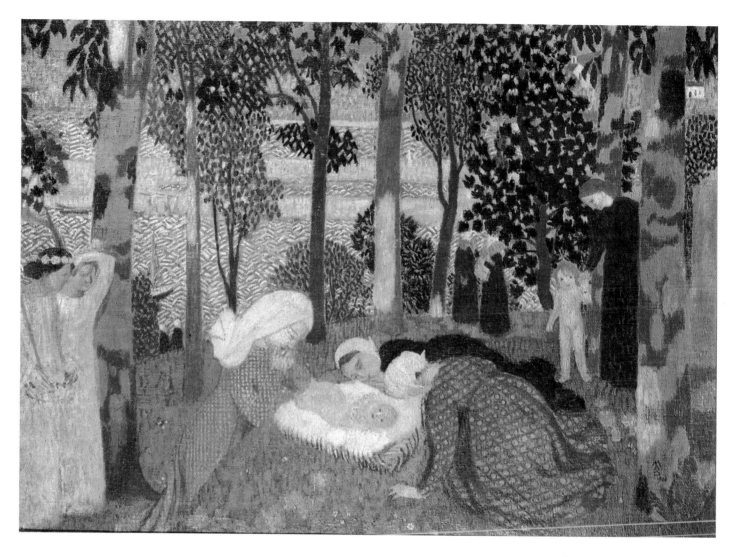

groups taken together form a unified division of the surface. Thus we have an array of heterogeneous elements whose distribution, flat drawing, and pastel, even saccharine, colouring, no longer play a purely descriptive role.

If we attempt to assess what thematic significance the details have for the whole, then we can only conclude that they are unrelated; but if we regard them as the components of flat, patterned surfaces, then they suddenly change in appearance and form a woven tapestry whose function is distinctly non-narrative.

If Denis succeeds here in unifying the painting's contents and creating the impression that not only do they all share the same location but that they are all alike in terms of spatial depth, then he does so by means of a kind of flat wickerwork texture that draws all the separate strands together. In the *Portrait of Mlle. Yvonne Lorelle in Three Poses*, he attempts the simultaneous representation of three events which in real life would of necessity occur at different points in time. He does this by bringing together three different views of the same person, one from the front, one from the back, and one in profile. This impression of simultaneity is increased by the fact that in the case of each view the location and the spatial extent are almost identical.

The following quotation taken from

11 Maurice Denis
Afternoon in the Wood, **1900**
Oil on canvas. 73 × 103 cm
New York, Museum of Modern Art
Mr. and Mrs. A. G. Altschul
Collection

Denis' own writings will serve as a final comment on this technique which we have only been able to outline here: 'Symbolism attempts above all to translate feelings and ideas into corresponding forms. Using themes taken from history and legend, it suggests, by means of combinations of colour and rhythmic line drawn from nature, that there exist between things mysterious and unsuspected affinities.'

43

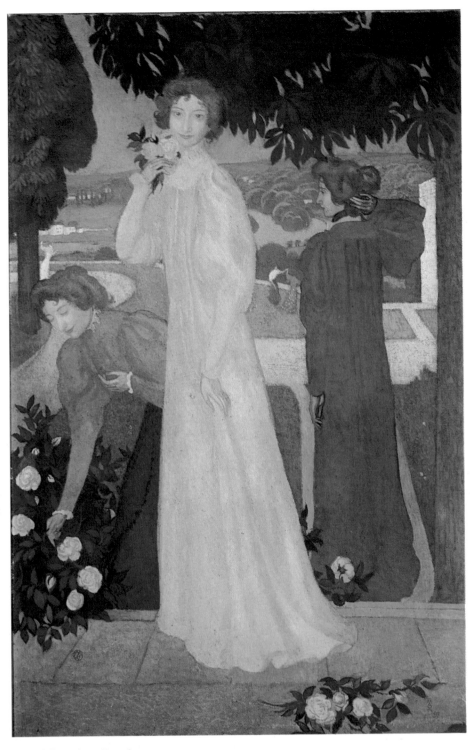

12 Maurice Denis
Portrait of Mlle. Yvonne Lorelle in Three Poses, **1897**
Oil on canvas. 170 × 110 cm
Toulouse, O. Rouart Collection

Gallén-Kallela, originally an exponent of Realism, as were most of his Scandinavian contemporaries in the 1880s, at first showed little sign of developing such an entirely original and monumental linear style, and thereby becoming one of the leading representatives of Finnish Symbolism and Art Nouveau. He made a name for himself not only as a graphic artist but also as a portrait painter. His designs for decorative metal work, textiles, coloured glass, and woodcuts, decisively influenced the development of applied arts in Finland.

Gallén-Kallela drew inspiration time and time again from the themes of the

Kalevala, the Finnish national epic; not a creation of the Dark Ages, however, but the work of E. Lönnrot, a doctor, who composed his verse epic in fifty cantos out of old Finnish folksongs, and published it in 1835. The 'atmosphere of the epic is not so much heroic as one of magic.' Its hero, Lemminkainen, in his attempt to win a woman's hand is obliged to perform a number of heroic deeds, one of which is to slay the Swan of Hell. On his way to the underworld he meets his death and can only be brought back to life by his own mother. In his elucidation of the painting's subject, the artist wrote the following words: 'with the pallor of a corpse, Lemminkainen lies on the ground by the bank of the dark expanse of water, across which the swan glides, contemptuously averting its gaze. The golden light of shimmering sunbeams gives the mother hope, and she sends the bee to fetch balm from the golden spring.'

The magical and frozen quality of the painting is quite in keeping with its literary source. The impression of artificiality results from the combination of applied and pure art techniques (the corpse of the hero which has the appearance of porcelain; the flowers in the foreground on the left that resemble metal candlesticks, together with the skull and bones; the metallic faces; the beard and hair; the line of stones at the edge of the water that bisects the painting diagonally; the almost stencilled-looking patches of blood on the rocks) which appear curiously stylized in that the similarity between their finish and that of the goods manufactured by skilled craftsmen is accentuated.

13 Axel Gallén-Kallela
The Mother of Lemminkainen, **1897**
Tempera on canvas. 85 × 118 cm
Helsinki, Ateneumin Taidemuseo

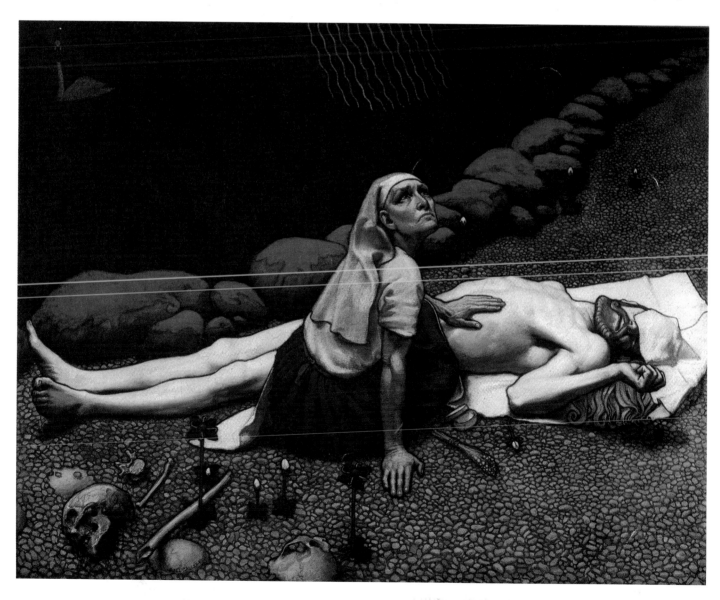

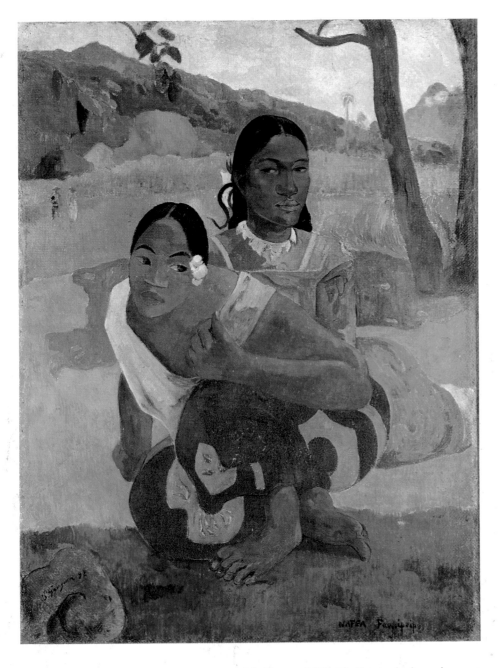

especially interested. Gauguin gave concrete visual expression to the nobility and beauty of non-Europeans. He juxtaposed pure colours on the basis of their interior resonance, and thus became one of the first to use patterns of fluid, sweeping lines in order to mark off flat, practically unmodelled sections of the surface. The sense of perspective that we have in the foreground becomes less and less pronounced in the background. With equal consistency he omitted characteristic detail and thus imparted to the figures a certain lack of individuality. This Synthetist manner of composition was taken over by Art Nouveau to become one of the later movement's most characteristic features. It is only recently that we have begun to appreciate Gauguin's stature as an artist; not only did he produce, in addition to his paintings, fine, two-dimensionally conceived woodcuts and wood sculptures inspired by native art, but he also exerted influence on other artists. His work and his conception of the artist's role found echoes in German Expressionism and in Fauvism, and the highly colourful way in which he decorated the various divisions of his picture was a source of inspiration to these working in the applied arts. *When Will You Marry?* is subdivided into one central area, occupied by two women. The one in the foreground sits in a crouching position with knees drawn up and the top half of the body bent forward. The one in the background sits upright with raised hand. Both bodies are combined to form a single figure which dominates the whole canvas and reaches out with its partly curved and partly angular outline into the adjacent areas in a fan-like fashion. Gauguin's particular interest in the compositional possibilities of a radially conceived central figure is made clearer in a preliminary study, *Tahitan Woman* (c. 1892), that he made for this painting. The women's faces are almond-shaped, that is, shaped as narrow ovals, not in any way to suggest their exotic character but rather to correspond with the radial conception of the whole figure. The similarity of these faces is made

14 Paul Gauguin
When Will You Marry?
1892. Oil on Canvas
101·5 × 77·5 cm
Basle
R. Staechlin Collection

One of the leading figures on the Post-Impressionist scene was **Gauguin**. Both the Pont-Aven group and the Nabis took their lead from him. He developed, together with Bernard (Ill. 3), the technique known as Cloisonnisme, which involved the interlocking and juxtaposition of separate shapes by means of robust outlines and pure homogeneous colours. Like other French Symbolists he painted in such a way that his canvases appear to be filled with highly solid objects which are to be enjoyed individually rather than collectively. In this respect they resemble Egyptian paintings in which he was

46

even greater by the exaggerated movement of the eyes, either to the right or to the left. The adjacent areas appear, by contrast, as a combination of flat horizontal layers which, taken as a whole, resemble a landscape whose clusters of trees and mountains are easily identifiable, but which contain coloured subdivisions which are not so easy to comprehend—for example, the rather amorphous bluish-violet expanse behind the two women could be regarded either as an area of shadow beneath the trees, as water, or simply as some non-descriptive colour figuration. The placing together along a horizontal plane of flat, colourful and firmly bounded zones in the central area, and the vertical stratification of flat zones in the surrounding areas creates a decorative structure that is not merely a form of embellishment but the

compositional principle that underlies the visual organization of the whole painting.

These features are even more apparent in Gauguin's *Vision After the Sermon.* Here, too, linearity and the flattening of the surface are accorded a major role. At the same time the representation of the theme is not so much an end in itself but rather an excuse to create an ornamental structure. Although the artist subtitled his painting *Jacob wrestling with the Angel,* he did not, in fact, allow his portrayal of this theme to dominate the canvas, placing it rather in the background; instead he gave us an impression of a random event and collection of people, viewed from a random position. All the people and objects in the painting (including the tree trunk that sweeps across the

canvas) more or less overlap and in many cases are rendered incomplete by the obtrusion of the frame. As a consequence, the edge of the canvas is embellished by a row of figures or coloured shapes, running from the bottom right to the top left, that resemble the decorative border of a carpet. Considered individually the women's bonnets retain their identity; but as the eye is induced to move along the whole row, they merge to become an association of non-descriptive, decorative forms. The large flat expanse of red that shows practically no sign of modelling, and from which the figures in combat

15 Paul Gauguin
Loss of Virginity, **1890–1**
Oil on canvas. 90 × 130 cm
Norfolk, Chrysler Museum

emerge to form a single, distinct shape, acts as a negatively contrasting background. If, however, we choose to regard the figures around the edge of the canvas as the backcloth, then the red expanse can be understood as a positively contrasting decorative form.

In a passage from one of his letters, which also sheds light on the *Loss of Virginity*, Gauguin had the following words to say about his preoccupation with symbols and the situation of the observer with respect to this: 'Yes, Puvis illustrates his idea, but he does not paint it . . . Puvis for example will call a painting *purity* and in order to express this idea he paints a maiden with a lily in her hand, a symbol that everyone is familiar with and therefore understands. To illustrate the same title Gauguin will paint a landscape with a transparently clear expanse of running water, not yet polluted by civilized people. Without going into details, Puvis and I are worlds apart. Puvis the painter is a scholar but no poet. I am no scholar but perhaps I am a poet.'

16 Paul Gauguin
Vision After the Sermon, **1888**
Oil on canvas. 73 × 92 cm
Edinburgh
National Gallery of Scotland

With the painting *Night* (1890) **Hodler** created a sensation in the Salon du Champ de Mars and thus attracted the attention of the critics. For this particular work the artist received the silver medal. In an interview given to Else Spiegel in 1904 for a Viennese magazine (the exhibition of the same year in Vienna established his European reputation) Hodler spoke about his artistic background and about his technique: 'What I especially prize in art is *form*. Everything else exists to serve form. And the most important of these servants is colour. I love clarity in a painting and that is why I very much like parallelism. In many of my paintings I have chosen four of five figures in order to express one and the same feeling because I know that the repetition of one and the same thing makes the impression stronger. I have a particular preference for five because an uneven number heightens the painting's sense of order and creates a natural centre point so that I can give an all the more concentrated expression to all five figures . . .

When I first started to paint, I used Impressionism as my model. Slowly, however, by dint of study and years of observation, I established my present aesthetic standpoint—clarity of form, simplicity of portrayal, and repetition of motifs.

My favourite artists are Dürer and the Italian Primitives. Of the moderns I especially admire Klimt. I love his frescoes above all; everything in them is tranquil and flowing, and he too has a liking for repetition, which is how he achieves his splendidly decorative effects' (Hodler, p. 23).

Together with portraits, in particular penetrating self-portraits in which he attempts to account for his life as an artist, Hodler's work displays a preference for paintings containing one or more figures. In the paintings *The Dejected*

17 Ferdinand Hodler
Transfiguration, c. **1903**
Oil on canvas. **110 × 64·5 cm**
49 Wuppertal, Von-der-Heydt Museum

(1892–1904), *Eurythmie* (1895), and others containing several figures, the dominant feature is the repetition of similar forms. This parallelism serves not only to increase the clarity and intensity of the painting's portrayal but also lends support to its monumental architecture. It is here that the accurate and generous use of firm outline comes into its own. 'The outline, or, as the eye sees it from any single position, the outer edge of the form' says Hodler 'does not only give expression to the three dimensions (height, width, and depth), but it also has a decorative and architectural function depending on how it contrasts with the other objects' (Loosli, p. 198). Monumental architecture, content, and the predominance of firm outline also characterize the paintings containing single figures, some of which are shown at the climax of an action, as in *The Mower* (1909), or *The Woodcutter* (1910), and others in intensely statuesque poses. In *Transfiguration*, in *Emotion* (1902) and in *Song from afar* (1906–7) among others, the figures appear in front of a stylized landscape that possesses almost no horizon and is reduced to a small number of elements, tending to align themselves with either the horizontal or vertical axis of the painting in order to create balance. These elements also serve to throw into relief the painting's decorative character that results from the use of a firm contour and the flatness of the surface. The figures acquire their particular appeal from their dress, gestures, and stance. Their garments' style links them to no specific era, often reaching the feet and further underlining their individual character. The

18 Ferdinand Hodler
The Spring, **1907–10**
Oil on canvas. 105 × 128 cm
Private Collection

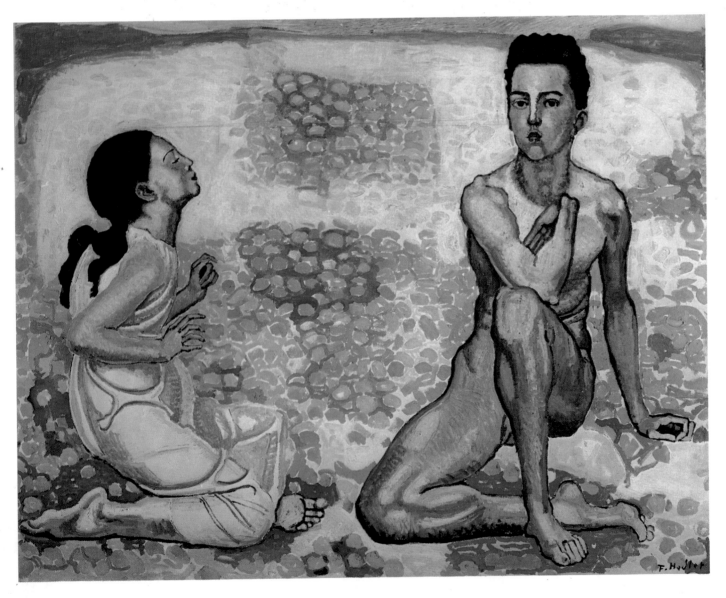

artist has the following words to say in this connection: 'It is through gesture that the artist is able to achieve great expressiveness. The way a man holds his body is a reflection of his soul. Gesture (beauty of movement) must be harmonized with the beauty of forms. The way in which clothing hangs, the drapery on the body, help us to see posture more clearly.'

As in the case of the paintings containing several figures, those containing two figures, such as *The Spring* and *The Dream*, deal neither with social relationships nor with scenes of action. The contents and architecture of all three types of painting (i.e. including the portraits) are designed to induce the observer to formulate a story, aided by the often literary title, or as Hodler himself put it, to form his own interpretation of 'the idea revealed by the form.'

We still await a complete assessment of the artist's splendid landscapes which are triumphs of his parallelistic style, such as *Evening Landscape* (1901) and *Sunset on Lake Geneva* (1915).

Hodler not only stands among the most important 'Stylist' artists at the turn of the century, he also paves the way for Expressionism and gives new impetus to monumental painting.

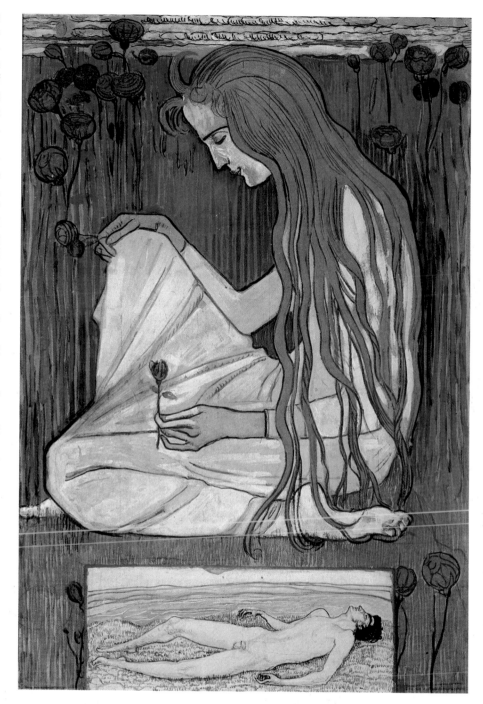

19 Ferdinand Hodler
The Dream, **1897–1903**
Pencil, pen, and brush, coloured crayons, watercolours, gouache and oil on brown paper, mounted on cardboard
88·6 × 69·7 cm
Zurich, Private Collection

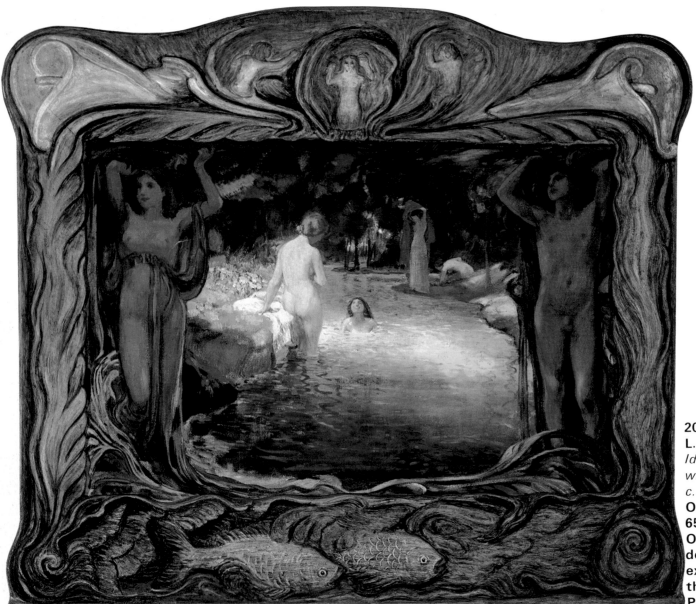

20
L. van Hofmann
*Idyllic Landscape
with Bathing Women*
c. 1900
Oil on canvas
65 × 96 cm
Original frame
designed and
executed by
the artist
Private Collection

In addition to being significantly influenced in his use of colour by Puvis de Chavannes (Ills. 45, 46) and A. Besnard, L. **von Hofmann**'s manner of relating figures to their spatial context owed much to the example of H. von Marées (Ill. 32). He was, moreover, the friend of Hoffmannsthal, Stefan George, and Däubler, whose works he illustrated. Hofmann's *Idyllic Landscape* is one of the most important of Art Nouveau's efforts to fuse frame and painting into an unbroken, organic whole, thus integrating a variety of media. The artist strives to create a sense of the continuous transition from the carved and painted frame, whose function is purely ornamental, to the more painterly bathing scene. At the same time the points at which the frame and painting meet are rendered compositionally effective by means of two painted motifs on the frame. The smoothness of this transition is further ensured by the painted plant motifs that provide a continuation for the carved plants on the frame. Woodcarving makes way for the application of paint to some previously sculptured forms, and this in its turn is superseded by painting proper. Consequently the observer is almost unaware of the transition from the frame's close-range figures in the foreground, that require a narrow focus, and the painting's long-range figures in the background that demand a wider focus. The bathing scene is so laid out on the picture that he can take it in at one glance without being unduly distracted by the figures on the frame.

Kandinsky, spokesman for the Blaue Reiter, drew inspiration in his early work from Art Nouveau, Russian folk art, and Neo-Impressionism in particular. The presence of these elements in his work accounts for its poetical lyricism, which becomes more and more independent of its descriptive role, finally leading to abstract and concrete art. It was in 1900 that he painted his first abstract watercolour. This is what Kandinsky said of his work: 'Whenever we experience the "secret soul" of all those things which we see with the naked eye, or at the end of a microscope, or through a telescope, then we are making use of our inward eye. It is this faculty that allows us to gain a glimpse of what exists at the very centre of things, beneath the hard shell which is their external form, and thus to perceive the inner "pulsation" of things with all our senses' (Hess, p. 87).

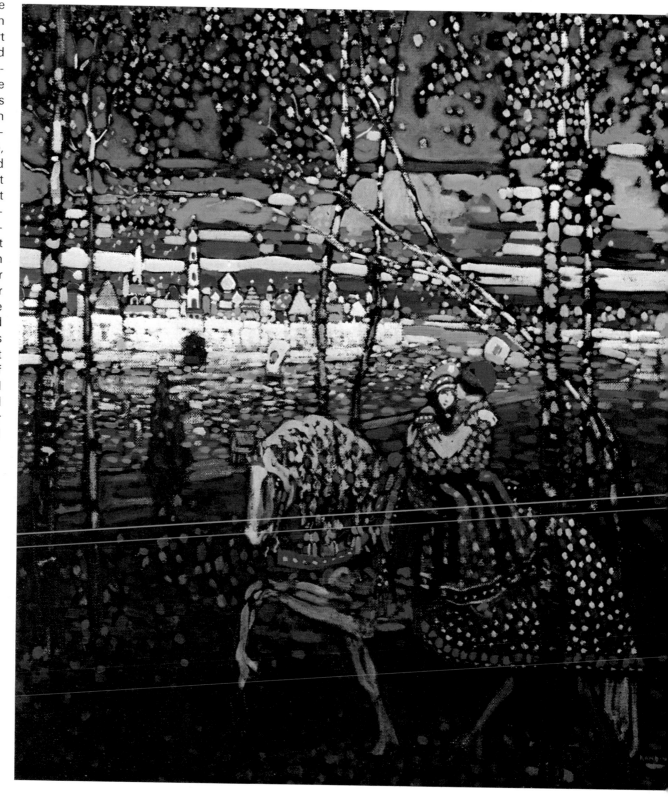

21 Wassily Kandinsky
Riding Couple, 1905–6
Oil on canvas. 55·5 × 50 cm
Munich, Städtische Galerie
im Lenbachhaus

53

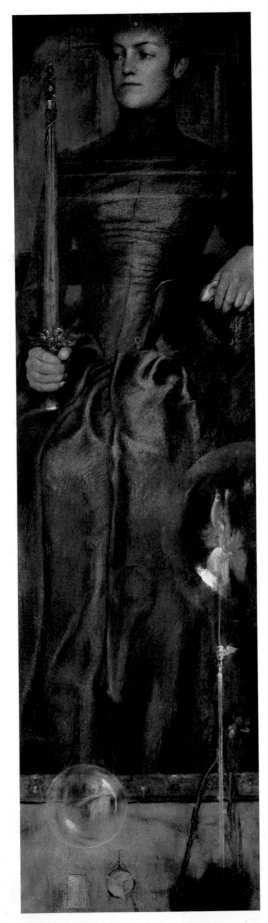

22 Fernand Knopff
Isolation, **1894**
Crayon on paper. 150 × 44 cm
Switzerland, Private Collection

It was at the Paris World Fair of 1899 that the painter, designer and sculptor Fernand **Knopff** first saw the works of Moreau (Ills. 37, 38) and the Pre-Raphaelites. These paintings made such a lasting impression on him that much of his subsequent work was to be strongly affected by them. Prior to this experience, and before he became the principal representative of Belgian Symbolism, which was one of the national strands of a phenomenon that was of European significance, Knopff painted pictures that were either Impressionist in conception or full of naturalist detail, choosing as his themes not only portraits and interiors whose predominant mood is one of melancholy, but also scenes of city thoroughfares. His best works are distinguished by the refinement of their pastel colouring, by their almost mystic intensity, and by their appearance of spectral unreality. Both Stuck (Ill. 58) in Munich and Klimt (Ills. 23-25) in Vienna, learnt from Knopff.

The painting *Isolation* is a typical example of Knopff's art. It demonstrates his ability to take a number of pictorial objects (in this case a person, whether male or female, seated or standing, is uncertain, wearing some form of clothing with a high collar, and bearing a sword or sceptre in its hand; a glass sphere within which we are able to see a vision; the first letters of Christ's name written in Greek letters; a plant-like formation on a stem or shaft with a winged head and blossom, etc.) and out of their mere juxtaposition on the canvas gradually to induce the observer to create an organic whole that is both intellectually and aesthetically satisfying.

23 Gustav Klimt
Salome, **1909**
Oil on canvas. 178 × 46 cm
Venice, Galleria d'Arte Moderna

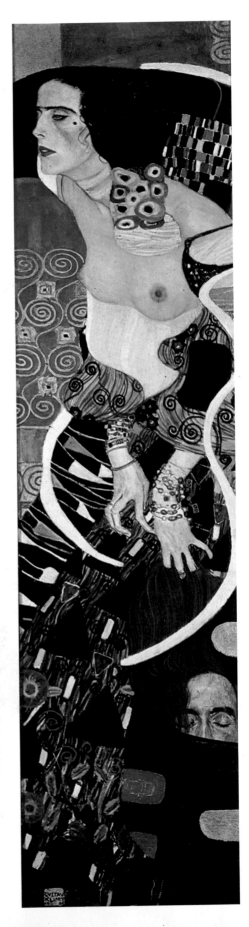

Vienna, which had always been the melting-pot of the most diverse artistic and cultural trends, was able to boast the artistic event of the turn of the century with the founding of the Secession in 1897. Among the fifty founder members were Mehoffer (Ill. 35) and Mucha (Ills. 40, 41); among those who joined by letter were Crane from London (Ills. 9, 9a), Klinger from Leipzig (Ills. 26, 27), Mackensen from Worpswede, Puvis de Chavannes from Paris (Ills. 45, 46), Segantini from Soglio di Val Bregaglia (Ills. 53, 54), and Stuck from Munich (Ill. 58). The *Ver Sacrum* (volume 1, 1898), was the mouthpiece of this newly founded Society of Austrian Visual Artists. Moreover, it was the only magazine, among the many others devoted to art or literature that came into existence at this time, to be published by a group of artists working together on a non-profit basis. The first president of the Vienna Secession and one of its founder members was Gustav **Klimt**, a pioneer of modern art in Austria. Klimt was equally active as practitioner of pure and applied art and as what one might call a 'diplomat' in artistic affairs, organizing events and acting as a spokesman for those painters associated with him. It is virtually impossible to give any really characteristic impression of this artist's work, for the number of exhibitions which he organized or participated in is immense.

Klimt's work is entirely typical of 'Stylist Art' as a whole in its choice of themes. He was particularly interested in exploring the thematic possibilities offered by the idea of female metamorphosis, whether in the context of a portrait or in the treatment of mythological and allegorical subjects. In addition, he painted pictures dealing with humanity as a whole, such as *Procession of the Dead* (1903), and landscapes such as *Poppy Meadow* (1907).

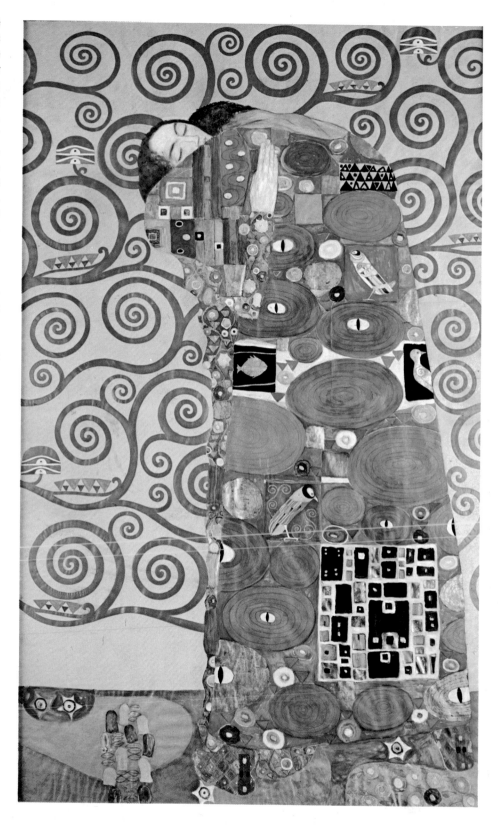

24 Gustav Klimt
The Fulfilment (The Kiss), c. **1909**
Watercolour and gouache on paper mounted on wood. 192 × 118 cm

Strasbourg, Musée d'Art Moderne

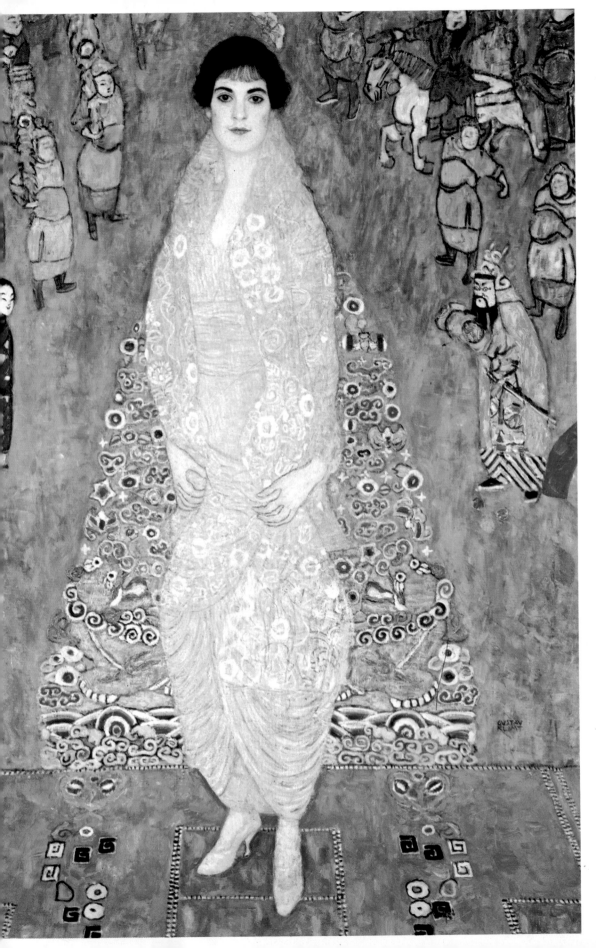

After 1905 Klimt developed a preference for gold surfaces as a means of pictorial organization. We see this technique applied, for example, in the plans which the artist submitted for the mosaic in the Palais Stoclet in Brussels. The building itself, which was the result of close co-operation between Joseph Hoffmann, the architect and a fellow member of the Secession, Klimt, and the Vienna workshops, was built between 1905 and 1911. This phase in Klimt's work has been called his 'golden style'. Our example, *The Fulfilment (The Kiss)*, is almost an exact copy of one of the plans submitted for the Stoclet mosaics. In his last creative years, from about 1912, Klimt changed over to a looser manner of painting, employing intense colours (*Portrait of Elisabeth Bachofen-Echt*).

The manner in which Klimt made thematic use of technique, marks him out as one of the exponents of 'Stylist Art' at the turn of the century, and thus accounts for his influence in the 20th century. As our examples show, and this is especially true of *Salome* and *The Kiss*, the painter constructs his work out of tiny shapes that resemble the tesserae of a mosaic; and as he does so, he ensures that this laborious process of construction acquires thematic significance. At the same time he knits the patterns and textures together by means of paint, thus adding a dimension which transcends any craft-like aspect.

Klimt combines geometrical and non-representational shapes with imitative forms (such as faces, hands, feet, breasts). The conception of the painting as a piece of non-applied art is particularly apparent where the artist not only clearly depicts animate and inanimate objects, such as skin and material, for what they are, but also allows the naked parts of the human body to serve an ornamental function as

25 Gustav Klimt
Portrait of Elisabeth Bachofen-Echt
c. **1914. Oil on canvas. 180 × 128 cm**
Private Collection

well as a realistically imitative one. Decorative figures are at the same time embellishments that closely resemble familiar objects, and part of the work's effect depends on this ambiguous interplay. Indeed, the naked parts of the body only become aesthetically pleasing once they are regarded as part of an ornamental configuration. This is true of the woman's face in *The Kiss*, for example; or of the hair of the man's head, the stretched-out fingers, or the bared breasts, in *Salome*.

Klimt's artistic achievement is distinguished by the richness of his invention with respect both to individual pieces of ornamentation and the decorative conception of the whole. In consequence the observer is no longer able to make a clear distinction between those elements that are to be assigned a decorative significance and those that are to be interpreted as representational items.

After studying in Karlsruhe, Berlin, Munich, and Brussels, **Klinger** settled in Leipzig. In addition to his work as a painter, he was, like a good number of artists at the turn of the century, active in artistic affairs as an organizer. In 1903 he became, together with M. Liebermann, E. van Uhde, and Count Kessler, a vice-president of the German Association of Artists. In 1905 he founded the Villa Romana, a studio in Florence.

'Hysterical Renaissance' was the name which Heinrich Mann gave to German art produced in those years of expansion between 1870 and the outbreak of the First World War. In giving it this name he was alluding to its superficial fixation on the human form, which would be placed in the foreground of a painting as close as possible to the observer. It would be solidly and three-dimensionally conceived and presented either naked or in some sumptuous costume. The remainder of the

painting would act as a foil to the principal figure or figures, serving merely to elaborate the theme in greater detail. Using such a compositional scheme as his starting point, Klinger over-emphasizes in his *Evening* relative size and spatial depth. At the same time the particular way in which he arranges his figures and adds subdued realistic colouring makes for a personification of evening that only occupies the foreground of the canvas. Klinger began to free himself, more and more, from such a pictorial conception, assigning a more prominent role to Symbolist elements, as in *The Blue Hour*. He expressed the idea behind this painting as follows: it was an attempt 'to give the best possible charac-

26 Max Klinger
Evening, **1882**
Oil on canvas. 76 × 126·5 cm
Darmstadt, Hessisches
Landesmuseum

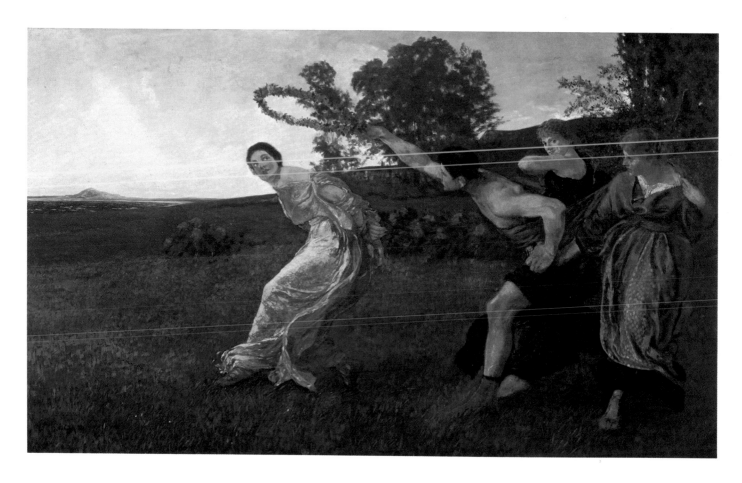

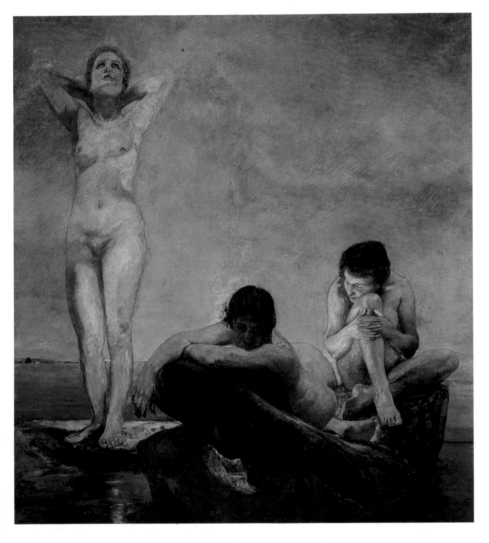

27 Max Klinger
The Blue Hour, **1890**
**Oil on canvas. 191·5 × 176 cm
Leipzig, Museum der Bildenden
Künste**

terization of three different kinds of silent meditation—the listless musings of one staring vacantly into the evening darkness, the uncanny unspoken unease of one looking into the fire, and finally, the almost visionary phantasies of one looking up into the heavens.' The fire, though hidden behind the rock and therefore scarcely visible, nevertheless acts as a source of light. Not only does it throw into relief the plasticity of the three figures in their different poses but it also creates with its richly nuanced blue and luminous combination of red and yellow a pre-dominating atmosphere of mystery that thus provides the painting with unity.

Klinger, who was much impressed by the work of Böcklin, saw painting and graphic art as two different areas of activity whose problems and corresponding solutions were not of the same nature. Writing on this subject, he said: 'I think that painting is, on account of the means that it uses, dependent on the external visible world, on nature and on the harmony of things . . .' His conception of graphic art and its creative possibilities makes it abundantly clear why Klinger's work in this field exerted a powerful influence on other artists. His aquatints, etchings, and lithographs, some of which are devoted to a cyclical treatment of a common theme, were not only a source of inspiration to Munch and his generation but have also affected the work of young modern artists such as H. Janssen and P.

Wunderlich. 'Graphic art is the true instrument of phantasy in the visual arts. It permits the omission of colour that would otherwise have given some kind of significance to each spot on the canvas. It allows the artist to reduce modelling to a minimum and also to place a fully modelled body against an undefined back-ground—or even against no background at all—without this device appearing objectionable or even so much as striking. In consequence the graphic artist has many means at his disposal with which to depict the fantastic; means which are only conditionally available to the painter and which, if overused, would create an impression of artificiality' (letter to J. Albers, February 24, 1884).

58

It was not until the 1930s that the Czechoslovakian painter, graphic artist and illustrator, **Kupka** was rediscovered in America. The Cubism and Abstract Art exhibition held at the Museum of Modern Art in New York gave special emphasis to the place of his pioneering works in the line of development leading up to abstract concrete art. The exhibition held in the Kunsthaus in Zurich at the beginning of 1976 confirmed this view.

His early works, such as the cycles *Gold*, *Peace*, and *Religion*, which he produced between 1902 and 1904, contain satirically perceptive treatments of political subjects. As in the case of Kandinsky (Ill. 21) and Mondrian, his work had its roots in 'Stylist Art' but he abandoned the use of ornament and decorative line in favour of abstraction.

He was particularly fond of organizing surfaces in terms of moving colours.

It is within this latter phase of development that *The Wave* belongs, a painting of large format which can be fruitfully compared with Maillol's work (Ill. 33) of the same title. Kupka painted his first version of this theme in 1902. The association of water with various beings was altogether conventional and was typical of the personification devices to be found in German art and elsewhere in the forty years preceding the First World War. In Crane we have horses, in Böcklin we have figures drawn from the realms of myth and imagination, in Gauguin and Maillol we have, as here, a female figure. Kupka's treatment of his theme is entirely in the manner of 'Stylist Art', particularly when

he adds ornamental flourishes to the realistic conception of the waves. Similarly, the sea in the foreground has a decorative aim and seems to have been cast like a net over the rocks and the squatting female figure.

28 František Kupka
The Wave, **1903**
Oil on canvas. 100 × 145 cm
Ostrava, Galérie Výtvarného Umění

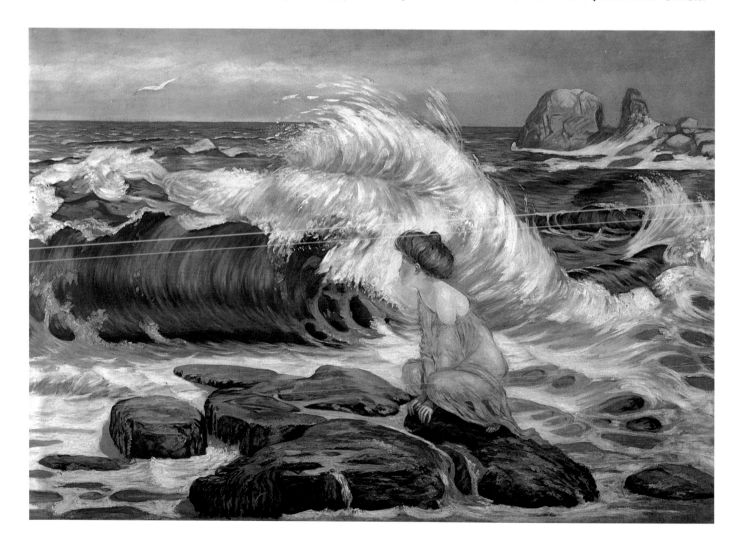

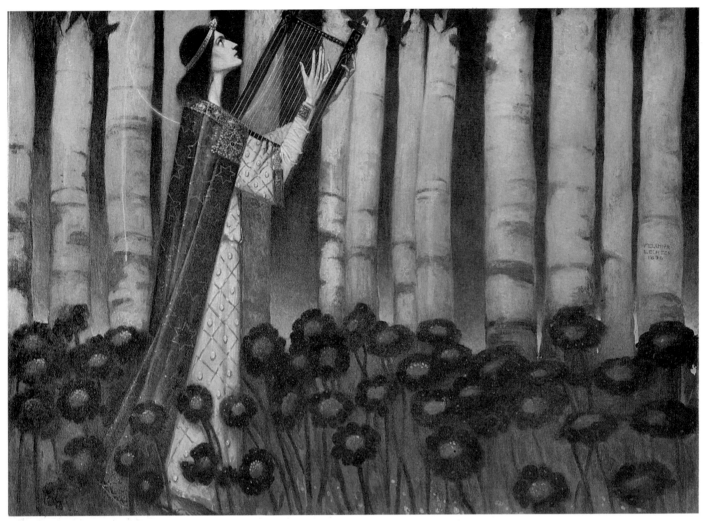

29
Melchior
Lechter
Orpheus
1896
Oil on canvas
80 × 108 cm
Münster in
Westphalia
Westfälisches
Landemuseum

The artist, who provided illustrations for the writings of Stefan George and Maurice Maeterlinck, whose full-scale design for the interior of the Pallenberg room in the Cologne Museum of Applied Arts and Crafts was awarded the Grand Prix at the Paris World Fair in 1900 and soon came to be regarded as a 'symbol of intellectual trends in Germany at the turn of the century'; the artist whose glass windows such as the *Lumen de Lumine*, finished in 1907 and now in the Munster Landes-museum, were, along with those of Mehoffer, some of the most important of their kind in Stylist Art; this artist, Melchior **Lechter**, has been consigned to obscurity. Even the exhibition held in Munster in 1965 to mark the one-hundredth anniversary of his birth was not enough to effect a reappraisal of his work and thus lead to a more accurate assessment of his contribution to 'Stylist Art'.

Lechter's *Orpheus* sheds light on the special relationship between applied art and painting. In his quest for a new style he was at pains to emphasize the original and unique features of his work. Against a flat background depicting a landscape that only permits a slow movement of the eyes, we have a decorative arrangement of non-representational plant formations: first a narrow zone of large, earth-coloured flowers on narrow stems, randomly distributed, then above these a number of tree-trunks arranged vertically in fours that shoot up through the canvas and disappear still incomplete (see introduction pp. 14–15). The manner of portraying the background is dependent more on suggestion than on the combined effect of individual details so that there is the greatest possible contrast between it and the strikingly erect figure of Orpheus, which neither casts a shadow nor possesses any articulation of the limbs. This figure, whose detail is austerely yet lovingly wrought, is the decorative centrepiece of the painting. Lechter does not assign a functional role to the various embellishments such as the slender hands, the face in half profile directed towards the sky, the blue star-covered cloak and the precious stones; rather does he regard ornament as the sacred essence of painting, that at the same time tells us something about the artist.

The Impressionists had sought to dissolve all those elements that gave an object definition and individual significance (local colour, line and three-dimensional form) into shimmering light. 'Stylist' artists approached nature and landscape painting in an entirely different way. They attempted to create lyrically conceived 'mood-paintings' depicting scenes infused with melancholy and heavy with meaning. Evening and early morning settings were preferred, not because of the peculiar qualities of their light and air, but because of the moods that were associated with them. In choosing this kind of subject matter, the 'Stylist' artist turned away from the depiction of spectacular events in nature that had been a feature of earlier landscape painters.

The work of **Leistikow** is distinguished also by an approach that marks a departure from the aesthetics of Impressionism and earlier landscape painting. If his landscapes have any affinity at all with those of other artists, then it is with the works of the Worpswede and Dachau groups. As a man of many gifts, Leistikow played an important role, together with Liebermann, in the organization of artistic affairs. Moreover, he was active as a journalist and, as was the case with many 'Stylist' artists, produced designs to be used in applied and commercial art. His sole interest as a painter was landscapes based on motifs drawn from the Brandenburg area in Northern Germany and the Scandinavian countries. Typical of these are his paintings of the Grunewald lakes near Berlin and

his *Danish Landscape with Villa*. Their characteristic features are a sense of tranquillity, an absence of finer details, and the symmetrical distribution of large flat surfaces containing only a small number of objects. Considerations of balance are not entirely disregarded, however, so that the ornamental details of smooth expanses of water and sombre groups of trees retain their maximum expressiveness. The final impression is one of canvases showing a sensitive use of colour, avoiding violent contrasts and brilliant hues as much as sharply defined shadows. For colour and line are subordinated to the demands of broadly laid-out contours.

30 Walter Leistikow
Danish Landscape with Villa
**Oil on canvas
80 × 100 cm
Vienna
Kunsthistorisches
Museum
Moderne
Galerie**

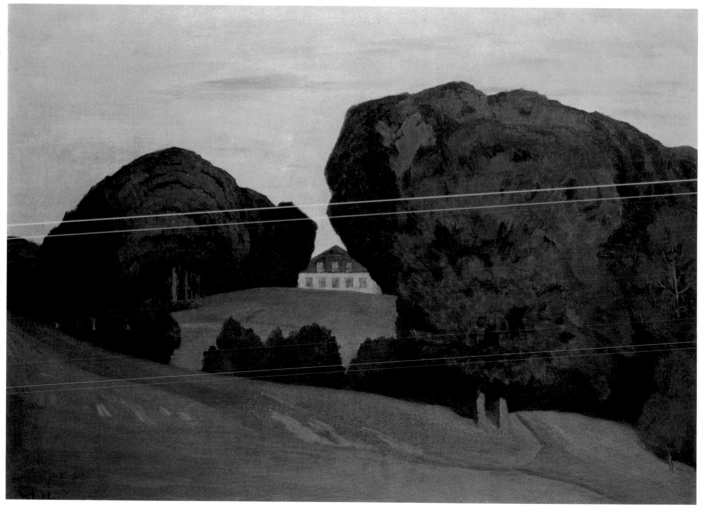

Mackintosh's coloured drawing is noticeable, not only for its restraint, but also for the high seriousness with which the artist endeavours to realize his ideal. He is not merely content to draw together into a whole a variety of stylistic motifs culled from many different sources, nor is he prepared to employ traditional methods of realistic portrayal or make use of a 'faux-naif' manner of execution. It was this refusal on his part to submit to a conservatively-minded, eclectic aesthetic that extended his reputation as an architect and designer of interiors far beyond Scotland's frontiers.

The first chandeliers and pieces of furniture that he produced around 1890 were distinguished by a new kind of clarity and by a rigorous, though not austere, organization of their often geometrically inspired components. His interior decorations are characterized by the use of long, curving lines and gracefully fashioned lattice work. This fondness for patterns resembling lattice or mesh work in the areas of small scale articulation is also reflected in the delicately wrought crystalline complexity of the illustrated watercolour with its small format. There is a striking contrast between the traditional title *Full Moon in September*, that leads us to expect perhaps a realistic treatment, and the novelty of the conception that allows the observer to stand back and appreciate anew an artist's response to nature. Lattice work of twigs and small branches alternating with small oval leaves and rather bigger circular patches of colour in yellowish brown, turquoise, and bright red, culminate in the round yellow form of the moon that rises behind this fine web-like arrangement. The eye, attracted first by the complex lattice work, is gradually led by way of the circular and oval patches towards the moon which appears to be supported or even trapped by the completely rounded wings of some fantastic female figure. The rich and variegated decoration of the lower half of the painting is matched by the intensely monochromatic bareness of the top half. These areas are balanced out in the centre, however, by forms that resemble cloud formations, and are typically Art Nouveau. Their configurations, silhouetted against the disc of the moon, have a spectral, even blossom-like appearance.

In the past the moon had been associated with that side of life remote from the sober reality of the everyday world—with madness, hidden passions, mysterious events, and the realm of fairytale. In Mackintosh's painting the moon itself is almost entirely divested of these associations, and what was formerly an archetypal symbol of the fantastic and subjective experience is reduced to a phenomenon of nature. The aesthetic quality of the painting lies rather in the contrast between the relatively unadorned appearance of the moon and the night sky with a highly complex and essentially non-representational pattern in the lower half of the picture.

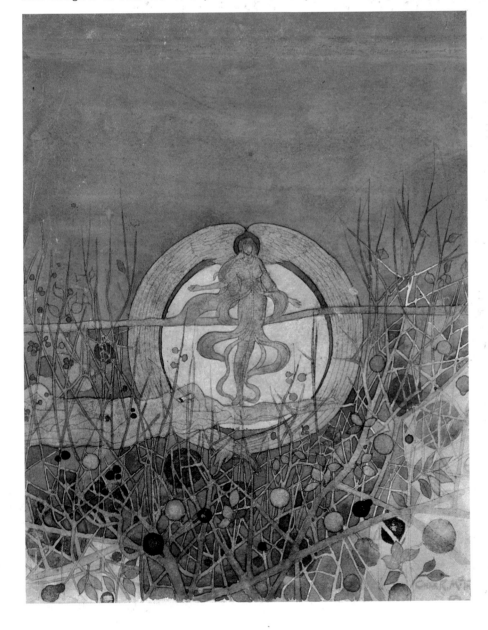

31 Charles Rennie Mackintosh
Full Moon in September, **1893**
Pencil and watercolour on paper
35·3 × 27·7 cm
Glasgow, Glasgow School of Art

An important forerunner of 'Stylist Art' at the turn of the century was Hans **von Marées**. Not only was he personally acquainted with Böcklin but he was also the close friend of two other men who made significant contributions to contemporary artistic life, C. Fiedler and the sculptor A. von Hildebrand. Hildebrand was the author of *The Problem of Form in the Visual Arts*, a polemical tract that was published in 1893, the year that also saw the first issue of *The Studio* in London. Fiedler's theoretical writings on art provided the basis for lively discussion on the significance of aesthetics within the more general framework of art criticism, and have furthermore remained influential until today.

Marées, who withdrew increasingly from the bourgeois society of an expansionist era, realized that there could be more to painting than what was required of it by its middle-class patrons, namely set themes, realistically conceived. Though his choice of subject matter might seem at first conventional he is not concerned with the education of the observer as some artist raised in a classical or idealistic tradition might be; he is more interested in the visual and compositional potential that his theme affords him: manipulation of space and perspective, the distribution and interrelationship of objects.

Portraits and nature studies featured prominently among the works that he created in his early realistic phase. But by the middle of the 'seventies he had developed that individual style which is characteristic of his major works such as *Ages of Man* (1877–8), *The Hesperides* (1884–7), and *The Golden Age* (two versions). His figures are naked, largely conceived and bounded by firm outlines. The simplification and distortion of their anatomical structures is undertaken so as to ensure architectural clarity. The individual groups of figures, seen either in the process of unhurried movement or at rest, divide the surface into a number of different zones in such a way that the canvas appears to be constituted of flat, overlapping layers, placed one behind the other. Moreover, an impression of social harmony is created not only by the manner in which the figures partially overlap and by the way they stand or sit with respect to each other, but also by the gently curving lines of the bodies. Marées, who was undoubtedly one of the most important colourists of the second half of the 19th century, contrasts warm, heavy, thickly-layered colours with a dark background. In so doing, he sought, as he put it, 'to steer a middle course between impotent pastiche and mindless virtuosity'. His work has even been described as one of 'syn-

32 Hans von Marées
The Golden Age, **first version 1879–85**
Oil, tempera, resin on wood
188·4 × 149·3 cm
Munich
Bayerische
Staatsgemäldesammlungen
Neue Pinakothek

thetic monumentality'. Marées achieved a marriage of form and content which was to have far-reaching consequences for later developments in 'Stylist Art'.

33 Aristide Maillol
The Wave, c. **1895**
Oil on canvas. 99 × 89 cm
Paris, Musée du Petit Palais

Maillol, who was at first active both as a sculptor and painter, came under Gauguin's spell in 1892. In 1893 he opened a studio for tapestry design where the style of his creations betrayed the influence of Ranson (Ill. 47) who was also associated with the Nabis. It was at this period that he produced paintings and decorative ceramics. After 1900, however, he devoted himself entirely to sculpture.

The compact composition, smooth surfaces, and firm outlines of his later sculptures, are features which are already present in his nude study *The Wave*. The almost square format is entirely filled by the surging water so that there is no indication either of an horizon or of perspectival depth. The female figure, shown in diagonally aligned profile and in the process of violent movement, dominates the canvas. Visual focus is directed towards contour, whether it be the outlines of the body or the foaming crests of the waves. But the features that carry the most architectural weight are the arm placed about the head and the tightly drawn up knee. They both introduce, by virtue of their angular shape, a foreign geometrical element into a context whose character is otherwise wholly determined by undulating wave formations; and taken together with the rest of the body, they create a flattening of the image. In this way the representational features of the painting can at the same time be interpreted as being part of some more abstract decorative scheme.

It was typical of **Matisse** that he was always ready to lay himself open to the influence of any one of the numerous different trends which made up the contemporary scene, incorporating those elements he thought to be of value and rejecting those that were foreign. One of the most decisive and lasting influences on his work, for example, was that of Moreau, the so-called liberal academic, with whom Matisse studied from 1895 onwards. His contribution to the Salon des Indépendants of 1905 placed him at the head of the Fauves. In 1908 he opened his own studio (the School of Matisse) where many young artists from all over Europe came to study.

The painting *Harmony in Red* is typical of his work. 'For me, expression is not to be found, say, in the passion that suddenly appears on a person's face or is the cause of some violent movement. Rather it is present in every aspect of the organization of one of my paintings: the space occupied by the bodies, the empty areas about them, the proportions, all these things play their part. Composition is the art of arranging a variety of elements in a decorative fashion in order to give expression to the artist's feelings. In a painting every component, whatever its significance, must be visible and perform the function allotted to it. Anything that serves no purpose in the painting by definition detracts from its effect. Each work is an harmonious whole; any superfluous detail would occupy a place in the observer's mind that should by rights have belonged to an essential detail. If composition is to be expressive, it must always take into consideration the size of the surface to be filled' (Matisse, p. 13).

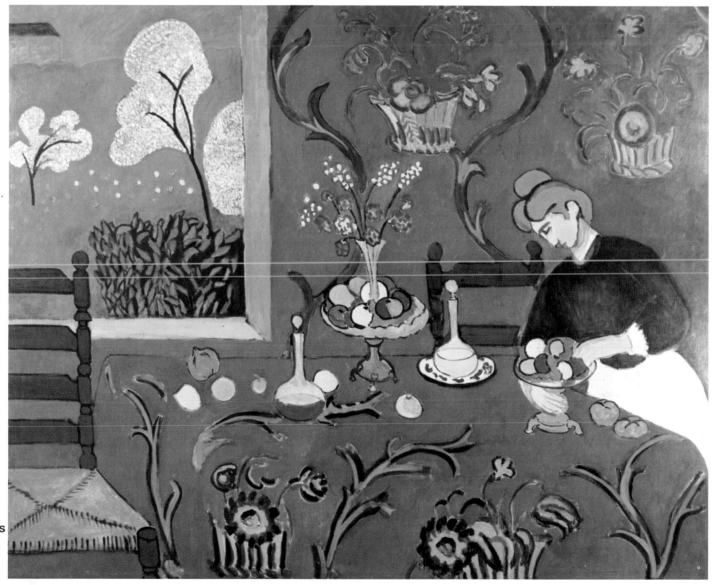

34 Henri Matisse
Harmony in Red, c. **1909**
Oil on canvas
180 × 220 cm
Leningrad
Ermitage

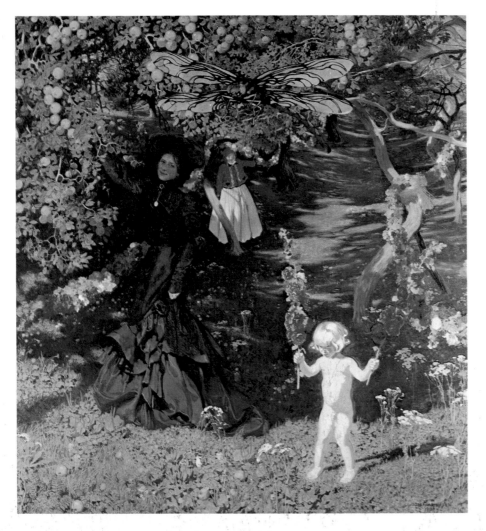

de Lumine (1907), rank as some of the most important contributions made by Art Nouveau to this medium. His book illustrations and designs for furniture and stage sets were instrumental in the reform of applied art in Poland. The techniques which he employed in his easel paintings had their roots in 19th-century realism, but he added other elements drawn from Impressionism, Symbolism, and Art Nouveau. *The Strange Garden*, one of his major works, is typical of this eclectic style: it shows a garden bathed in glorious sunshine, in which are three figures, a naked child holding flowers, a lady of upper class origins wearing a hat and an elegant blue dress to the left of the centre, and in the background an older woman dressed in folk-costume whose diminutive size gives her a puppet-like appearance.

The decorative sub-division of the picture into well-defined areas articulated by means of vertical, horizontal, or undulating lines; the extreme isolation of the loosely grouped figures that help to mark off the different sub-divisions; the use of silhouette to throw into relief the two women and the child; the flowers with their air of artificiality despite the summery setting; and above all the oversized dragon-fly whose thickly veined wings are made out of gold-leaf; all these features underline the painting's conception, which is difficult to interpret despite the realistically conceived scenario. At the same time the figures and the details demand such a narrow-focus approach that the eye of the observer cannot avoid examining every feature individually. In the process, however, he receives no guidance from the painting as to which elements are significant and which are not. Though each feature appears to be isolated from the rest, they merge to form a sensuous combination of symbol and decoration.

35 Józef Mehoffer
The Strange Garden, 1903
Oil on canvas. 217 × 208 cm
Warsaw, National Museum

The work of the Polish artist **Mehoffer** includes not only oil paintings (portraits, paintings depicting more than one figure, interiors, and landscapes) but also murals and other forms of applied art. He worked for forty years on the thirteen glass windows for the choir and aisles of the collegiate church of St. Nicholas in Fribourg, Switzerland. These, together with similar works by Lechter, in particular his *Lumen*

Millais, whose gifts were recognized very early on, joined the Royal Academy in 1840 at the age of eleven. In the revolutionary year of 1848 he founded the Pre-Raphaelite brotherhood together with Hunt and Rossetti. His work is predominantly historical or religious in content but he also painted landscapes, using combinations of luminous hues and coloured shadow.

Two myths connected with water played a very important role in 'Stylist Art': one was the legend of Narcissus, painted by Vallotton, for example (III. 65); the other was the legend of Ophelia as Shakespeare told it in *Hamlet*. This preoccupation with the tale of Ophelia can also be found in literature. Rimbaud, Laforgue, and Heym all wrote poems about her fate.

Millais depicts the final part of the story: Ophelia, who has become deranged, sings and strews about her flowers, as she gives herself to the water. Literary and pictorial representations of the theme focus on the desire for self-oblivion and union with the rest of creation. Millais' *Ophelia* must have struck the contemporary observers as odd because its photographic realism, of necessity, emphasizes the ungraceful helplessness of the girl's appearance, as she gradually sinks into the water.

36 John Everett Millais
Ophelia, **1852**
Oil on canvas. 76 × 112 cm
London, Tate Gallery

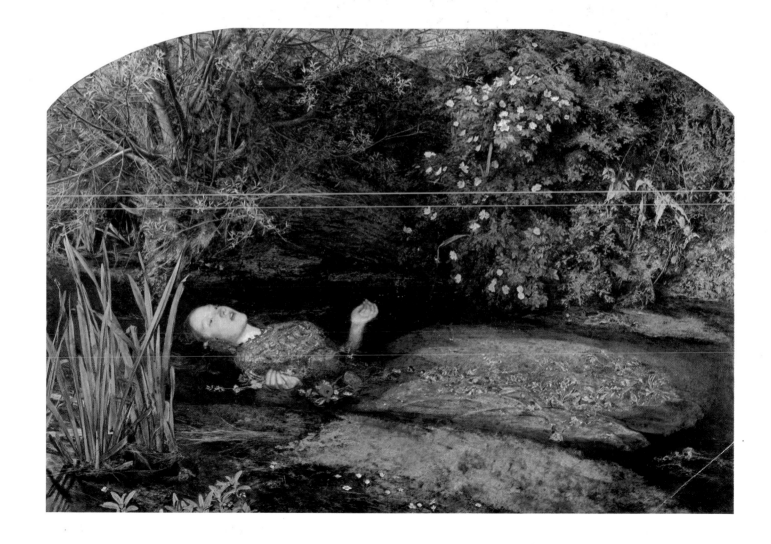

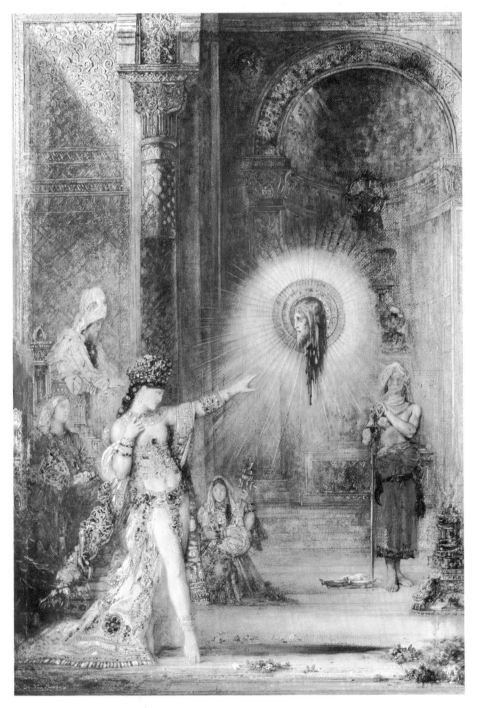

37 Gustave Moreau
The Apparition, **1876**
Watercolour
Paris Louvre, Cabinet des Dessins

The rediscovery of Gustave **Moreau**, which was a direct outcome of the growing research into the 19th century, created something of a sensation. This was particularly the case in Germany, where no museum possessed a single painting of his. Moreau, in fact, bequeathed nearly all his work to the Musée Moreau in Paris.

Burne-Jones (Ill. 8) was supposed to have told Oscar Wilde that the more materialistic science became, the more angels he would paint. This statement shows what Symbolist Art regarded as its most important concern, namely, the attempt to stem the tide of scientific and materialistic rationalism. Moreau himself touches on this subject in a statement he made to one of his favourite pupils, G. Rouault: 'I believe neither in that which I touch nor in that which I see. I believe only in that which I do not see, in that alone which I feel' (Lankheit, p. 29).

In such terms Moreau formulated the conviction shared by all Symbolist artists that the scientific view of the world was a hollow fruitless lie which they had a duty to unmask. It is in this light that we must see not only their desire to live against the grain but also their faith in a private language of visual symbols that was in no way concerned with a merely literal representation of the external world. Considerations of architecture and the use of technical devices for their own sake count more than the happy rendering of some scene taken from the real world. In choosing themes suitable for representation, Moreau drew on a wide variety of sources ranging from the Bible, classical myth and Homer, through to Ovid, Dante, and La Fontaine. The majority of his figures are cast in one of two moulds: either as a handsome, well-proportioned but effeminate youth or melancholy hero, or as an embodiment of woman in her original state, a naive and unsuspecting creature infatuated with the unknown and in love with evil in the guise of perverse and devilish seduction. It is hardly surprising, then, that Orpheus, Salome, sirens, chimeras, and the Sphinx should all figure prominently in Symbolist

paintings. Indeed, Salome, who was regarded as perhaps the most notorious example of the *femme fatale*, was the subject of no less than six different paintings at a single exhibition held in Baden-Baden. Among contemporary portrayals of this theme the most famous is undoubtedly the one by Moreau which we have reproduced here.

Galatea is characterized by a fan-like composition, as has already been pointed out in the introduction. In his watercolour *The Apparition*, which found its way into many homes as an engraving by Bracquemont (the version in oils of the same theme differs in some respects from the one reproduced here), Moreau makes this fan-like figuration also play an essential thematic role. It is, both in terms of its colouring and articulation, decisive for the character of the painting as a whole; the head of John the Baptist, which appears in the painting to float unsupported in mid-air, is made secure by the vertical alignment of architecture and figures.

J. K. Huysmans, who might almost be said to have proclaimed the Symbolist aesthetic from the roof tops, spoke of Moreau's 'tiara-crowned, female idols, sitting erect on their thrones whose steps are encrusted with masses of strange flowers'. No one has described better than Marcel Proust how the paintings of the 'goldsmith' Moreau, as Gauguin called him, were able to extend into the everyday world of the observer: 'When people saw Gustave Moreau's paintings, there was a fashion for sumptuous clothes, for things that were taken out of their natural context and turned into symbols; tortoises had to serve as lyres, flowers crowning a forehead had to be a symbol of death, and, whereas in the past the desire to return to untrammelled nature had led to the belief that a statue spoilt a field, people felt and wanted the beauty found in a land of art where statues proliferated on cliffs (as in Moreau's *Sappho*), and they liked to regard people and objects as the mental means through which the spirit of the poet—who alone was enabled to arrange them— moved, jumping from one to the next: from

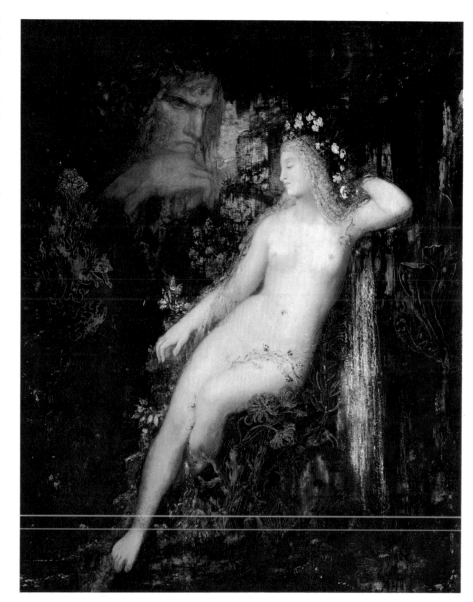

38 Gustave Moreau
Galatea, **1880–1**
Oil on canvas. 85 × 67 cm
Paris, R. Lebel Collection

the flowers which encircle a statue to the statue itself, from the statue to the goddess who passes not far away, from the tortoise to the lyre, while the flowers of a corsage almost become jewels and almost stuffs' (Jullian, p. 228).

One of the leaders of the English Socialist movement was William **Morris**. He was active, not only as a poet and writer on art, but also as a typographer and craftsman. In 1890, at the height of his artistic fame, he wrote *News from Nowhere*, a utopian social novel. An admirer of Gothic architecture, painting and manuscript illumination, he sought to incorporate certain features of medieval life into his own workshops.

His attempts to become a painter were unsuccessful despite his association with the Pre-Raphaelite brotherhood, particularly Rossetti (Ill. 50). He then turned to applied art where he was above all concerned to put a stop to the encroaching, and as he saw it, pernicious influence of industrial mass-production. In order to carry out his ideas for reform, not only of applied arts but also of book illustration, he founded his own workshops. The predilection that his designs show for organic plant-like and floral motifs mark him out as a forerunner of Art Nouveau.

The influence of Morris' ideas, designs, and craft products, was enormous and should not be underestimated. Walter Gropius, the founder of the German Bauhaus, regarded himself as a descendant of Ruskin and Morris.

Marigold is one of a number of designs offered by the firm Morris & Co. for the brightly coloured cotton fabric with linen binding known as chintz. The designs were originally manufactured on a factory basis by T. Wardle but later they were executed by hand using vegetable dyes in a workshop founded by Morris at Merton Abbey in 1881. The pattern consists of an undulating main shoot that splits to form two lateral shoots each of which then loops back on itself and culminates in a large blossom. Those areas which lie outside the shoot configurations are filled with small blossom-covered branches.

39 William Morris
Marigold, **1876**
Watercolour. 96·5 × 53·3 cm
Walthamstow, W. Morris Gallery 70

Mucha painted his *Slavia* during the three years he spent in America between 1906 and 1909. A leading American industrial magnate, J. Crane, was having a house built by Sullivan in the style of Art Nouveau. Being especially interested in the Slav problem and nationalist movements in East Europe, he commissioned Mucha to paint his daughter as the goddess Slavia, who was a symbolic embodiment of the identity and aspirations of the Slav peoples in Bohemia, Moravia, and Slovakia. Mucha had painted a first version of the work (without the ring in the goddess' hand) in 1907, when it was intended as a poster for the Prague insurance company Slavia; in 1918 the later version, commissioned by Crane, appeared on the 100 Krone banknotes of the newly founded Czechoslovakian state which were printed in America.

Slavia, with her ring of perfection or eternity, the sword of valour, the eagle that is the emblem of the Austro-Hungarian empire, and the two swallows (possibly inspired by a similar symbol used in Christian iconography to express the quest for self reliant maturity), is typical of the artist's work. Though he saw himself as a painter, he became world famous as a designer of posters such as *Monaco, Monte Carlo*. His participation in the Paris World Fair of 1900 led to the expression *Style Mucha*.

Like other Symbolists Mucha was particularly fond of depicting the archetypal woman. Even in his posters the women have an exotic air about them; maiden-like yet of no specific age, urbane and sophisticated yet of no particular era. Their pose, gestures, and expression convey a sense of unreality.

Although his subject-matter is characteristically Symbolist in conception, in terms of its manner of execution it is

40 Alphons Mucha
Slavia, **1908**
Oil and tempera on canvas
154 × 92·5 cm
71 **Prague, National Gallery**

typically Art Nouveau. Nature as such does not feature in his work; but the artist does employ synthetic plants and flowers to suggest artificiality in visual terms. The depiction of the female symbol in the centre of the canvas is matched by the floral configurations in the adjacent subordinate areas. At the same time the artist creates an overall impression of flatness in order to balance out the symmetrical and asymmetrical parts of the picture in a rhythmical fashion. In this way he succeeds in bringing back to cohesion the agitated lines of the symmetrical and asymmetrical areas; these are also distinguished by a complex interweaving of small-scale linear detail that often seems to be purely decorative in function, thus emphasizing the poster-like character of these works. Mucha's ability to create unity out of disparate elements, contrasting a central figure with associated, yet often extraneous embellishment, has exercised a significant influence on modern commercial art.

41 Alphons Mucha
Monaco, Monte Carlo, **1897**
Colour lithography
Weert
H. F. Smeets Collection

MONACO·MONTE-CARLO

72

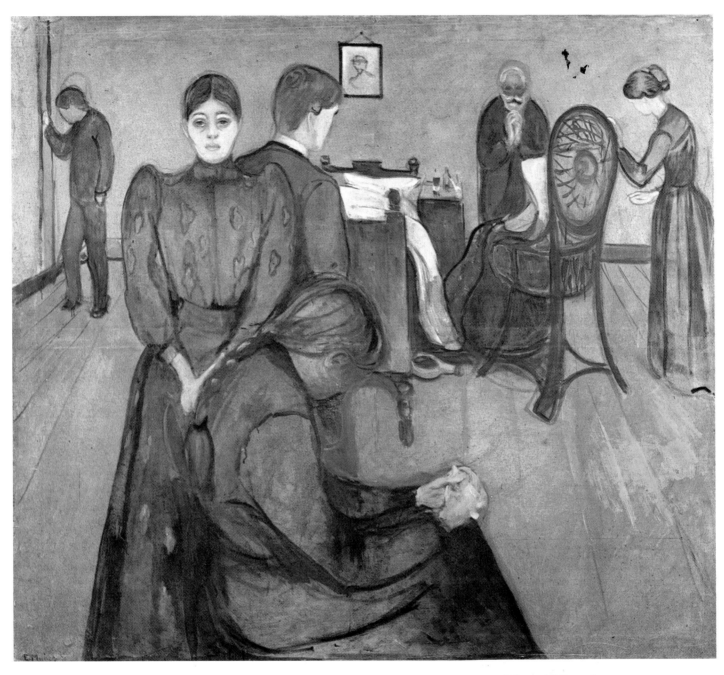

If one were to ask who were the most important representatives of 'Stylist Art', then the answer would certainly have to include Hodler (Ills. 17–19), Klimt (Ills. 23–25), and Munch.

Munch was an artist whose usage of Symbolist themes was not only vivid but often so shockingly blatant that his works were much admired by the Expressionists. Using psychology, symbols, and occasion-ally myth, as his means of visual expression he created an original synthesis of elements drawn in particular from trends in French Symbolism and Art Nouveau. In addition to painting landscapes in whose mysteri-ously pale light and magically enchanted atmosphere we can sense the 'scream of Nature' (Munch) he was attracted again and again to the portrayal of those aspects of life familiar to all human beings—

42 Edvard Munch
Death Chamber, **1894–5**
Casein colours on canvas
150 × 167·5 cm
Oslo, National Gallery

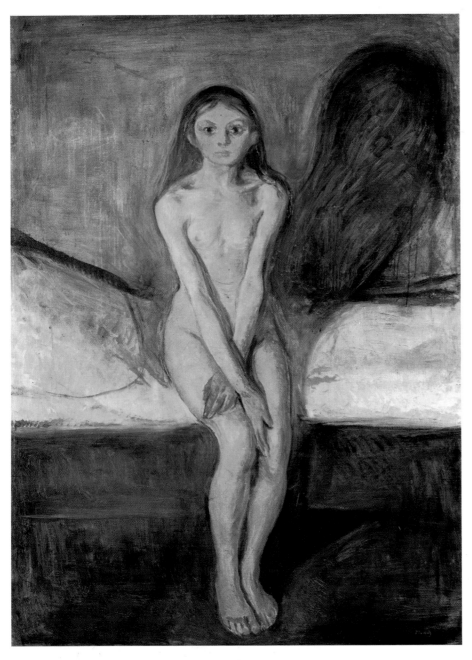

jealousy, fear, illness, puberty, old age, and death.

The *tableaux vivants* in which allegorical figures were replaced by living persons—for example, the Dutch soldiers in Rembrandt's *Nightwatch*—provide us with a model for an illuminating comparison. If, in the case of the *tableau vivant*, the observer is reminded of some visual portrayal of the same theme and is called upon to guess what it is, Munch's *Chamber of Death*, though resembling a *tableau vivant*, obliges the observer to recall similar scenes from his own experience in real life and to imagine the different ways in which they bore themselves in the presence of death.

This painting, *Chamber of Death*, is also a representation and analysis of the death of the painter's sister, Johanne Sophie, who died when she was fourteen. As is the case in several of Munch's paintings, there are several versions of this work, of which the one reproduced here is the most complete.

The version of *Puberty* which we also reproduce was painted in Berlin and follows in the footsteps of a previous painting of 1886, now lost through fire.

43 Edvard Munch
Puberty, **1894**
Oil on canvas. 150 × 110 cm
Oslo, National Gallery

Petrow-Wodkin, who died in Leningrad in 1935, was active both as a painter and a writer. In the twenties he developed his own theory of colour and space (the so-called 'spherical perspective'). During his years as a student he travelled widely in Western Europe where he encountered and became familiar with the work of Böcklin (Ills. 5, 6), Stuck (Ill. 58), Puvis de Chavannes (Ills. 45, 46), and Denis (Ills. 10-12). Even the paintings of Hodler (Ills. 17-19) were not without influence on his work.

The Shore is one of his early pieces and was produced in France, before he returned to St. Petersburg in 1908. It interests us less on account of its dry, pale colours, that betray the direct influence of French Symbolism, than of the way in which the whole visual organization is dependent on gently undulating lines or sweeping curves. Moreover, the outlines retain this quality irrespective of what they are depicting so that there is tension between the representational and non-representational use of curves. By thus imparting a sense of movement to the whole surface, the artist manages not only to create the impression of an organic association between the animate and in-animate elements in the painting but also to link the remarkably static figures. The observer, aided by the affinities between the various colours as well as by the expression, gestures, and pose of the women, is invited to supply his own interpretation.

44
Kusma Sergeyevich Petrow-Wodkin
Shore, **1908**
Oil on canvas. 128 × 159 cm
Leningrad
Russisches Staatsmuseum

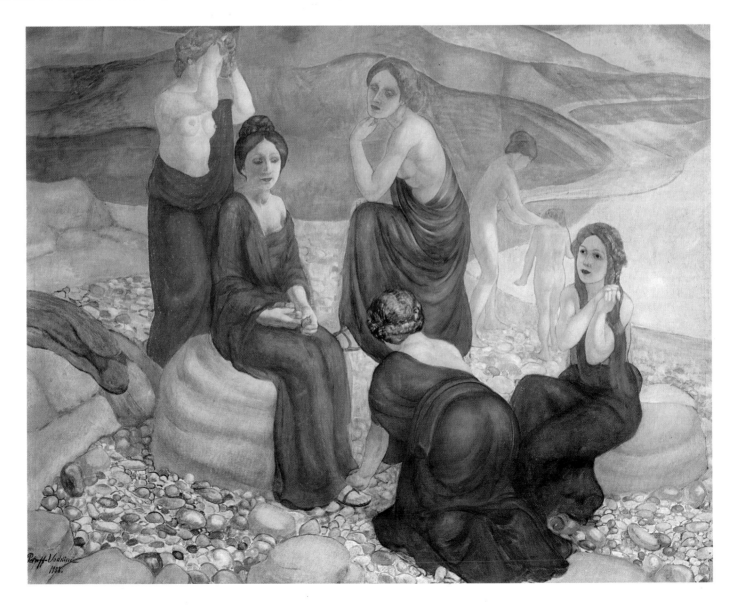

Hope was one of the paintings of **Puvis de Chavannes** that, together with *The Lost Son* (1878) and *The Poor Fisherman* (1881), exerted considerable influence on the younger representatives of the Symbolist movement. Gauguin, for example, possessed a reproduction of this painting;

45 Pierre Puvis de Chavannes
Hope, c. **1871**
Oil on canvas. 70 × 82 cm
Paris, Musée du Louvre

and it was in fact the Pont-Aven group, in particular, who admired the readily intelligible visual organization of his paintings, the broken colour and the consequent absence of luminosity, the unacademic choice of subject matter, and the curiously rigid appearance of the contents.

The artist was, for the most part, self-taught, although he did work for a short time in the studio of Delacroix. It was not until the 'sixties that he caught the public's eye and then his fame rested on the com-

missions he received for large murals, from, for example, the town hall in Poitiers (1875), the Sorbonne in Paris (1887), and the museum in Rouen (1890). That his reputation in America did not extend beyond that of a mural painter is shown by the commission he received to do murals for the museum in Boston.

Hope was occasioned by the Franco-Prussian war in 1870. A girl sits in almost full frontal position on a piece of cloth draped over a pile of stones. In one hand

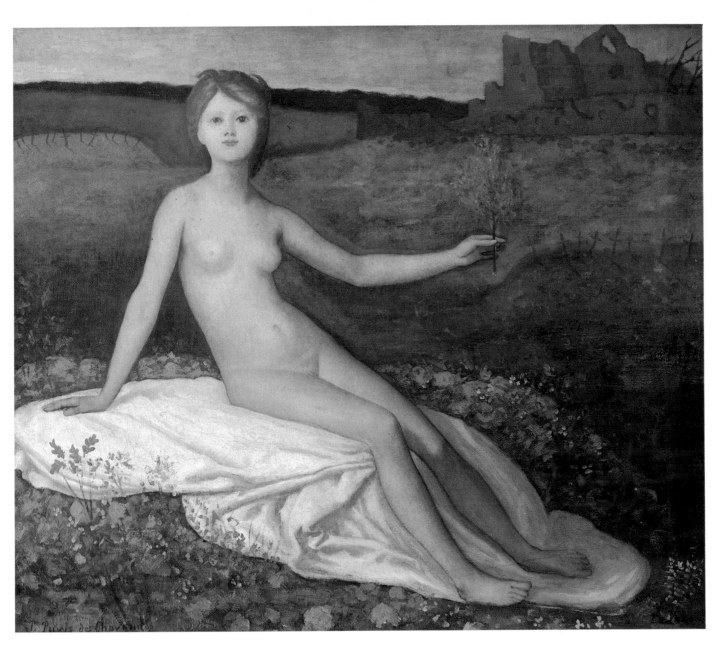

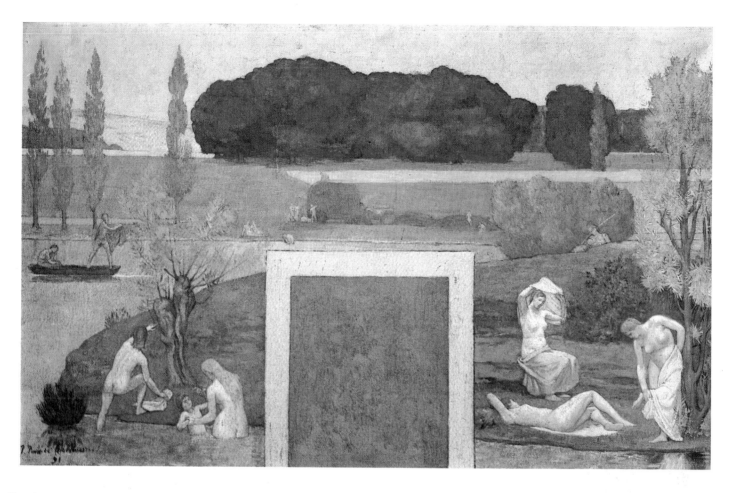

she bears an olive branch, the traditional sign of peace and reconciliation. Behind her there is a landscape with ruins that harbours dead trees and tumuli to the right and left; it is only in the area directly adjacent to the girl that flowers and grass appear. These, too, like the youthfulness of the girl and the dawn on the horizon are emblems of hope. The overriding impression of simplicity, of ready intelligibility of the composition, and the clearly recognizable identity of the objects, cause the observer to ignore the manner in which the painting is executed. But closer inspection reveals that the image is composed of flat forms, both small and large, which are so clearly marked off from each other as to appear insular. This relative isolation of objects, such as the tumulus on the right, the green space behind the nude, the tumulus in the top left-hand corner, the green space behind, and the ruins, means

that individual details are thrown into relief. The task of the observer is, then, to take such details as the precarious and ungainly pose of the nude, and interpret them in the light of the painting's title.

The painting *The Summer* was a design for a mural in the entrance hall of the Town Hall in Paris, in which the artist had to allow for the door. As in the case of all his other works in this medium, he did not execute the mural as a fresco but as an oil painting whose coloration is distinctly fresco-like in appearance. The present work reveals an insular distribution of clearly defined areas, such as we find in *Hope*, but whose isolation is further accentuated by other elements such as groups of bathing figures, fishermen, haymakers, clusters of trees, the tongue of land, water, meadows, fields, and sky. In the work of Puvis the potential disunity of the separate zones is counter-acted by

46 Pierre Puvis de Chavannes
The Summer, **1891**
Oil on canvas. 54 × 86 cm
Paris, Musée du Petit Palais

the presence of some central unifying motif: in *Hope* the female nude whose body can be regarded as radiating outwards into the surrounding canvas; in *The Summer* the figures and trees that cut across several zones at once. He developed even further the cloissonnist tendencies derived from Bernard (Ill. 3), but at the same time achieved a general unity through a pattern of firmly bounding contours that played no representational role.

77

Ranson was, of all the members of the Nabis group, the one most interested in the applied arts. His tapestries, of which he designed a good number (he was requested to do some for S. Bing's 'Art Nouveau' salon in Paris) betray, in the the composition of their figures, a classical training. His wife, who taught handicrafts at the academy which he himself had

founded in 1908 and who directed the institution after his death, executed his designs on embroidery canvas using thick wool. The painting which we reproduce here is an artificial landscape in the true sense of the word. If in Bernard (Ill. 3) the vertical stratification of areas and their constituent elements is still not divorced from its descriptive function of representing a recognizable landscape, in Ranson the relationship is reversed, and considerations of representation are made subordinate to those of stratification.

The *Nabi-Landscape* consists of four horizontally aligned bands that, reading from the bottom upwards, are coloured green, red, yellow, and once again green.

These are filled with a variety of forms, some of which are coloured and bounded by firm contours, while others are merely outlined. On the bottom green band we have a series of stylized forms that have been painted in by stencil: large plants alternate at regular intervals with insects and tiny flowers. A bearded man dressed in a blue robe and cloak and adorned with ear-ring and bracelet plucks one of the blossoms from the ornamental border. The painter, however, is not so much interested in the man's action but rather in the decorative unity which it gives to the left-hand corner of the canvas.

The painting is dominated by an undulating line that begins with the circular shape

47 Paul Ranson
Nabi-Landscape, **1890**
Oil on canvas. 91 × 118 cm
Private Collection

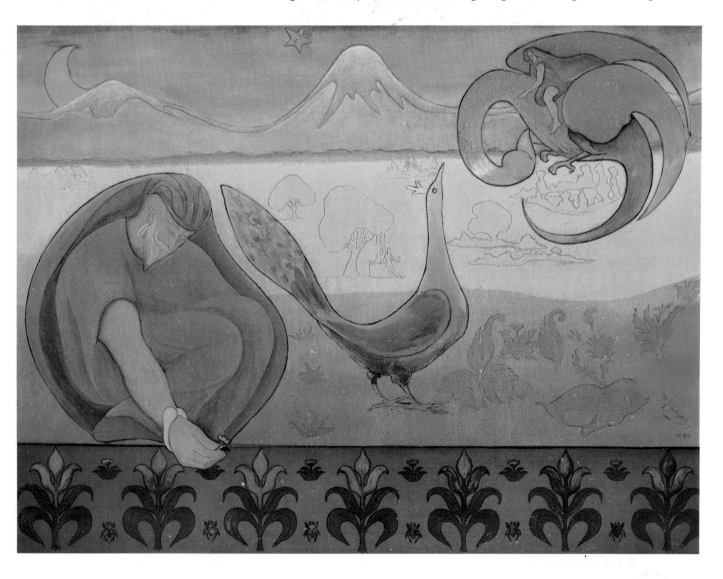

of the man's cloak, is then taken up by the peacock, and culminates in the circle formed by the fabulous bird-like creature, receiving its final echo in the clearly silhouetted mountain peaks. The pinkish white caps of the mountains are reminiscent of the patches of blood that decorated the lake shore in Gallén-Kallela's *Mother of Lemminkainen* (III. 13). Though the identity of each object is easily ascertainable, the nature of their relationship to each other is impossible to make out—indeed, it is this very difficulty of interpreting the correspondences between colours and the implications arising from the relative positions of the objects that seems to constitute the subject matter of the painting.

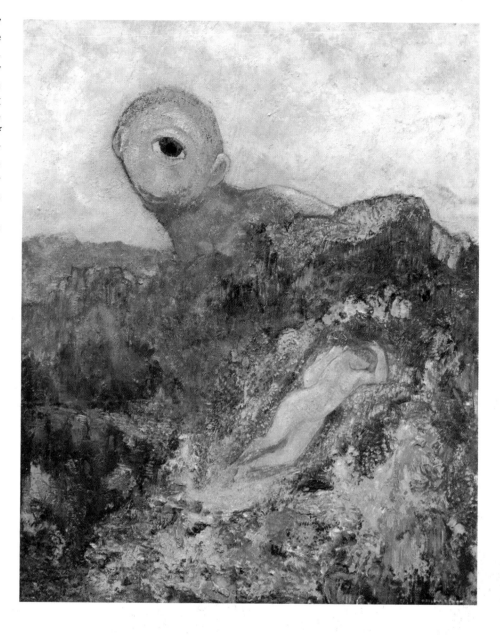

48 Odilon Redon
The Cyclops, c. **1898–1900**
Oil on wood. 64 × 51 cm
Otterlo, Rijksmuseum Kröller-Müller

1913 is a year that occupies an important place in the history of modern art on two accounts: not only did it witness the dissolution of the Berlin Expressionist group the Brücke, but it also marked a great step forward in the career of **Redon**. The forty works that he exhibited at the Armory Show in New York were a great success, so much so that a large number of his works entered American collections.

Until his fortieth year Redon's reputation was based almost entirely on his drawings and lithographs such as *The Dream* (1879), *The Origins* (1883), *For Edgar Allan Poe* (1882), *Homage to Goya* (1885), and *Visions* (1891). It is therefore hardly surprising that Redon's paintings were for a long time overshadowed by his graphic works, particularly as contemporary critics continued to devote all their attention to

the latter until the end of the century. It was not until the 'nineties that the artist began to take greater interest in painting, and there is no doubt that his pastel drawings are some of the finest that

'Stylist Art' has produced. In his oil painting *The Cyclops*, whose distinctive appearance is the result of thickly applied paint that has been partly smoothed over, the artist once again took up the theme of the single-eyed monster which he had already illustrated in his sequences of lithographs entitled *The Origins*, 'a kind of smiling, horrid cyclops'. In his drawings the outlines of what are clearly recognizable objects are obscured by the interplay of white, grey, and black, which leaves us uncertain as to the meaning of the composition. In his oil painting, *The Cyclops*, Redon achieves a similar effect and the observer is left to find his own meaning by carefully scrutinizing the picture (see introduction p. 9).

In his portraits and flower paintings, most of which were created after 1900, the artist was no longer concerned to 'bring to life, in a human way and in accordance with the laws of probability, beings which are improbable, by making the logic of the visible serve, as much as possible, that of the invisible'; rather he devoted his attention to the visual organization of colour and form. Despite the freshness of their colours these works retain that 'strange charm that once excited us in the notturnos and romances of graphic art' (Denis).

49 Odilon Redon
Portrait of Miss Violette Heyman, **1910**
Crayon. 72 × 92 cm
Cleveland Museum of Art

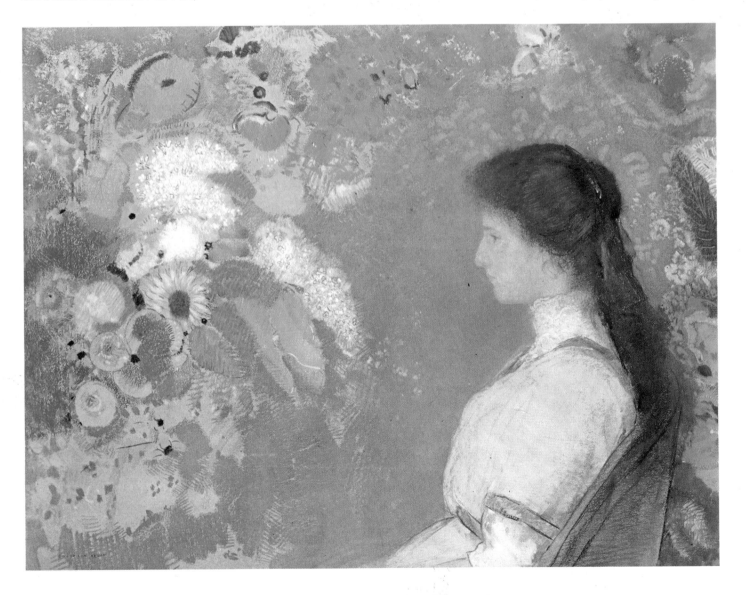

Rossetti, who achieved fame not only as a painter and graphic artist but also as a poet, came from a literary family. His father, Gabriele Rossetti, was a professor of Italian literature and a Dante specialist who had emigrated to England from his native Italy for political reasons. He also wrote patriotic and religious poems. His sister Christina Georgina, was the author of sonnets, stories, and fairy tales in a rather melancholy vein. Already by 1850 her painter brother had published a first volume of poems, which was soon to be followed by others. In 1886 his collected works appeared in two volumes and the poems contained in these often shed valuable light on the obscure symbolism of his paintings. He translated early Italian poetry such as Dante's *Vita Nuova* and wrote critical essays on both art and poetry. In 1848 he founded, along with a number of other artists, the Pre-Raphaelite Brotherhood which at first received unusually rough treatment from the critics. He was, furthermore, responsible for the magazine *Germ*, the short-lived publication associated with the movement that only survived four issues. It contained sections devoted to literature and the visual arts. In addition to his paintings he also produced woodcuts and watercolours intended as illustrations for the works of Dante, Shakespeare, and contemporary English poets; as well as handicraft designs for the workshop Morris, Marshall, Faulkner and Co., of which he had been a founder member in 1861.

La Ghirlandata is one of Rossetti's most famous paintings. A young girl, of indefinite age, sits amidst flowers and foliage, playing a harp. The top right- and left-hand corners of the painting are occupied by the heads of two other women, one of whom is winged. Green, brown, and a brownish-white flesh colour, are the dominant hues. The over-riding impression created by the painting is one of a harmony that is ethereal and far removed from the real world. The artist achieves this effect by a carefully balanced arrangement of figures and objects that takes into account their size and colouring and which avoids

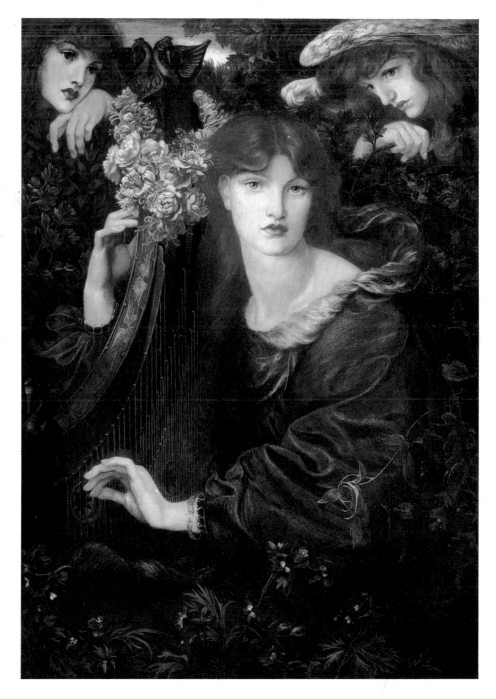

any sense of disruption. Unlike the work of the Symbolists proper, however, *La Ghirlandata* is too self-contained to allow participation on the part of the observer; not only is the visual detail self-explanatory and easy to assimilate, but the subject matter does not seem to demand an interpretation. We are left therefore to enjoy the

50 Dante Gabriel Rossetti
La Ghirlandata, **1873**
Oil on canvas. 115 × 87 cm
London, Guildhall Art Gallery

purely painterly virtues of the work which compensate for the slightly insipid, even saccharine quality of its appearance.

It is only in the last two decades that exhibitions and various publications have brought the public into contact with the work of Egon **Schiele**. His somewhat chequered career, in which recognition and success went hand in hand with all kinds of humiliating experiences and difficulties, was cut short by an early death.

In 1909, after frequent quarrelling with his teacher, he left the Vienna Academy together with a number of other young artists and formed with them the New Art Group. In 1912 his erotic drawings landed him in prison for twenty-four days on a charge of distributing obscene literature. That incident elicited the following response from the artist: 'In the course of the interrogation the judge seized one of the confiscated drawings and solemnly set fire to it with a candle flame: auto-da-fé, Savonarola, Inquisition, The Middle Ages! Expurgation! Hypocrisy!—why don't people go into museums and destroy the finest products of our artistic heritage? Whoever denies sexuality is not only an idiot but also insults his own parents in a most despicable fashion' (Schiele, p. 31).

Despite such experiences, however, the artist's fame continued to grow. In 1912 three of his works were exhibited in Cologne. In Munich some of his paintings were shown together with others by members of the Blaue Reiter.

Like Kokoschka, Schiele was much influenced by Klimt. The subjects that he preferred to represent were landscapes and the human figure. He often employed angular shapes and broken lines to articulate both detail and large scale structure, aligning these elements in either a vertical or horizontal dimension. This technique destroys any sense of harmonious or fluid movement, replacing it with a staccato and broken composition; and in the representation of figures it leads to curious poses and an apparent dislocation of limbs.

In his *Portrait of Friederike Maria Beer*, one of his more tightly knit works, he painted the daughter of the owner of the Kaiserbar in Vienna lying on the floor. The impression that the figure conveys of being suspended in mid-air prompted the artist's suggestion that the painting be attached to the ceiling.

51 **Egon Schiele**
Portrait of Friederike Maria Beer, **1914**
Oil on canvas. 190 × 120·5 cm
Private Collection

The name of **Schmithals** is mentioned in very few reference books dealing with modern art. Nevertheless he was one of the most important representatives of the Art Nouveau style, as it evolved in Munich at the turn of the century. The movement was dominated by the personality of the Swiss sculptor H. Olbrist, who founded, together with the fellow sculptor W. Debschitz, a studio intended to promote both the teaching of pure and applied art, and the creation of original work. It was at this same studio that Schmithals received his earliest training. He began by studying applied art, making designs for carpets, for example; but he soon changed over to painting. It was during this same period that he completed his *Weeping Willow by Night*, reproduced here for the

first time. It is painted on paper using tempera, pastels and charcoal, a technique that the artist developed in many of his later works.

Using a clearly defined object as his starting point, namely a weeping willow, the artist creates a network of fine branches that cover the whole of the surface. The branches, which are silhouetted black against the background, appear to be slotted together in sections, marked by dashes of gold. All these features combine to create a night scene that is striking in its eerie intensity. If in this painting the ostensible subject matter is merely the pretext for linear decoration, then the same is true of other works in which the artist further develops this approach: the portrayal of glaciers, whirlpools, ravines, and

flames, is subordinated to the compositional and decorative possibilities afforded by the shapes associated with these phenomena.

After 1910 Schmithals turned his attention more and more to architecture and interior decoration. He founded, together with W. V. Weresin, the Association of Interior Designers and in 1914 he displayed some of his own interiors, characterized by their straight lines and sparse furnishings, at the famous Werkbund Exhibition in Cologne. In the Second World War most of his work was destroyed. Though already an old man by this time, his rediscovery in the wake of the 1958 Munich exhibition *Breakthrough to Modern Art* inspired him to recreate many of his paintings, aided by old photographs.

52 Hans Schmithals
Weeping Willow by Night
c. **1903–4**
Tempera crayon, charcoal on paper
52 × 72 cm
Bad Kreuznach, Private Collection

That **Segantini** was able to refer to his later paintings as 'Symbolist poetry' shows how much he had abandoned the strictly naturalistic aesthetics embodied in his earliest work. The products of his Symbolist phase, characterized by an allegorical treatment of predominantly mystical themes, demand a full imaginative response from the observer who is expected to take account of every detail. In a letter to his poet-friend Tumiati, dated October 2, 1896, Segantini wrote about his conception of the observer's role in the light of one of his major works, *Amor at the Fountain of Life*: 'I send you the photograph of my most recent painting. It shows the happy and carefree love of the woman, and the reflective love of the man, both of whom are drawn to each other by the natural urges of youth and Spring. The path along which they tread is narrow and lined with blossoming alpine roses. They are dressed in white (which suggests the white of lilies, the traditional symbol for purity). "Eternal love" say the red rhododendrons,

"Eternal hope" answer the evergreens. A mystic angel, whose bearing betrays a feeling of unease, spreads one of his great wings over the mysterious fountain of life. The living water gushes out of the living rock, both of which are symbols of eternity. By means of the whites, greens, and reds I sought to refresh the eye, to intoxicate it with sweet, harmonious sounds. It was particularly in the shades of green that I sought to suggest this' (Segantini, p. 86).

In his answer to Tolstoy's question *What is Art?*, published in the *Ver Sacrum* in 1898, Segantini looked for inspiration not only to Pre-Raphaelite ideas but also to other sources such as Morris' social Utopianism and Wagner's aesthetic theories. 'The chosen one, who is filled with a pure and overpowering love for art, shall leave behind riches and all his kin. Bereft of all material possessions, he shall enter into the presence of that community of artists who appear to correspond to his ideal. Such communities will be found in

53 Giovanni Segantini
The Wicked Mother, **1897**
Crayon on cardboard. 40 × 73 cm
Zurich, Kunsthaus

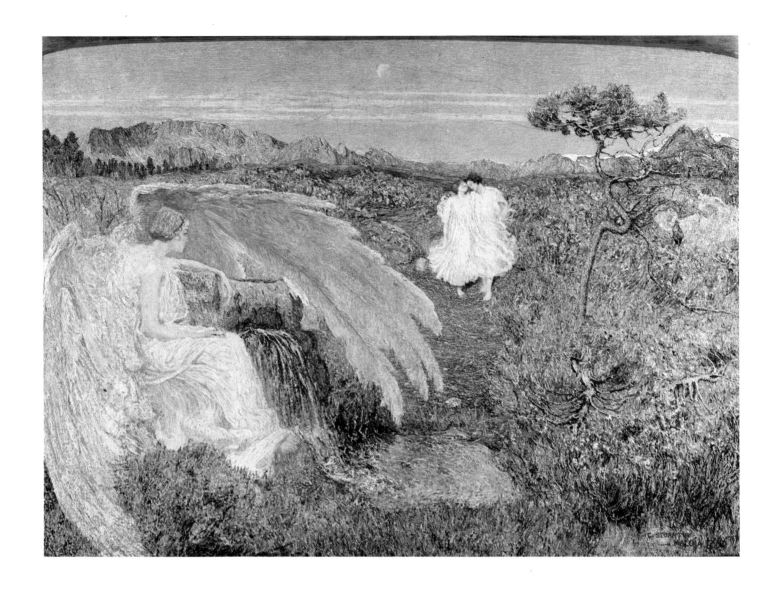

all lands; there will be gathered together artists of every age who like him have abandoned their family and all their goods and chattels to devote their life to the cultivation of beauty and every intellectual gift. It is by them that the novice will be received. There all the arts will be represented, and all those who need an artist, whether it be for a single individual or for the community, will turn to the leader of the whole society; at this point the latter will name those artists who can fulfil the need in question. These artists will make designs and have them carried out, or execute the designs themselves, depending on the situation. They will be able to do the drawing, modelling, and engraving not only for private houses but also for public buildings and places of congregation; for every furnishing up to and including the necessary spoons; for frescoes and every kind of decoration from the column base to the capital; for glass, iron, and every kind of metal and wood. As a reward for their work they will receive from the community the basic necessities of life—food and clothing' (Segantini, p. 44).

54 Giovanni Segantini
Amor at the Fountain of Life, **1896**
Oil on canvas. 75 × 100 cm
Milan, Civica Galleria d'Arte Moderna

Sérusier was one of the painters most closely associated with the Nabis, among whom were other artists who had also studied at the Académie Julian such as Denis, Bonnard, Ranson, and Vuillard. He was important to the group in a number of ways: not only did he invent the name, but he also acted as a kind of publicity agent for the new theories that the group was developing. Furthermore, since he had been the first to meet Gauguin in 1888, it was he who was entrusted with giving a regular report on the latter's activities to a meeting of the group held each week. He exhibited in the Salon des Indépendants, in the Salon d'Automne, and also with the Brussels-based group La Libre Ésthetique.

It was Gauguin's encouragement that helped Sérusier to develop his theory of the correspondences of pictorial elements, and of the harmony of colours and forms. It later formed the basis both of his lectures at the Académie Ranson and of a book entitled *The ABC of Painting* (1921).

The painting *Melancholy* shows a small naked figure, sitting in the foreground of a landscape with head in hand. The elements are so arranged that any sense of perspective is avoided. The sub-division of the surface, created either by fine contours or by the juxtaposition of different masses of colour, is not based on geometrical forms; but neither can the shapes be assigned any specific identity as can the objects in the canvases of Bernard (Ill. 3). To verify this we need only look for a moment at the flat patch of violet above the head of the solitary figure. The observer is induced to see this varied association of flat zones as a landscape by the inclusion of the cluster of trees in the top right hand corner and by the unusually lofty horizon. But once the observer has drawn this conclusion, he is unable to go any further and identify clearly any objects, their local colouring, and relative positions. Denis wrote, of a similar land-

55 Paul Sérusier
Landscape, 1912
Oil on canvas. 34 × 49 cm
Paris, Musée Nationale d'Art Moderne

scape by Sérusier, that the observer was confronted by 'a landscape without form, a mere combination of violet, green, and other pure colours, applied straight from the tube, hardly mixed with white.'

The rhythmic variation of flat surfaces, whose melancholic colouring gives unity to the painting, allows no one area of the canvas to dominate any other.

The Fauves spring to mind as a parallel here, but with an important difference—whereas the Fauves would readily combine a recognizable object with an independent pattern of colour (for example, Vlaminck's *The Red Trees*, 1906, in which red alternates with green and yellow), Sérusier's colour associations are often more realistically conceived yet attached to flat surfaces whose identity is not entirely distinct.

Sérusier, like other Symbolist artists, does not attempt to differentiate one element from another by the use of what are in realistic terms 'correct' colours. He arranges the contents of his canvas in such a way as to emphasize the affinities that exist between the various shades of some particular hue. The carefully juxtaposed areas of sombre colour in *Melancholy*, for example, can be seen as an attempt to induce a similar mood in the observer. The small figure in the foreground, whose pose exemplifies a more traditional means of representing grief or sadness, no longer has the central importance that would have been accorded to it in earlier paintings.

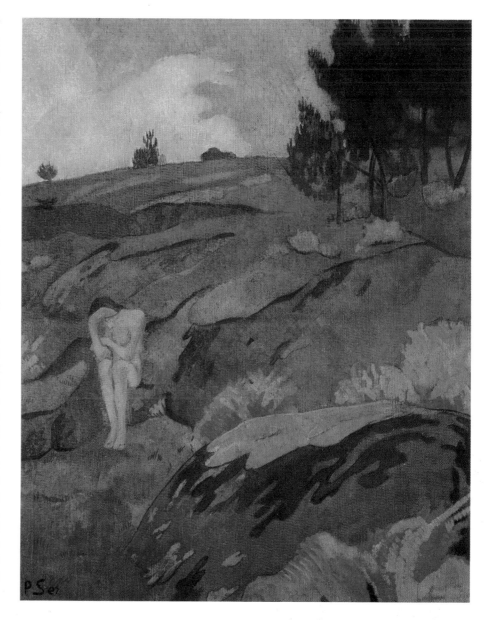

56 Paul Sérusier
Melancholy, c. **1890**
Oil on canvas. 73 × 60 cm
Private Collection

Carl **Strathmann** was until recently a little-known artist. Thanks to an exhibition held in Bonn in 1976, however, the general public became aware for the first time of the originality and diversity of this artist's work. It included oil paintings, watercolours, drawings, and commercial art (posters, illustrations, drawings for the magazine *Youth*, designs for carpets, tapestries, and glazed tiles). Strathmann, who had been dismissed from the Düsseldorf Academy because of 'lack of talent', studied in Weimar and then in Munich

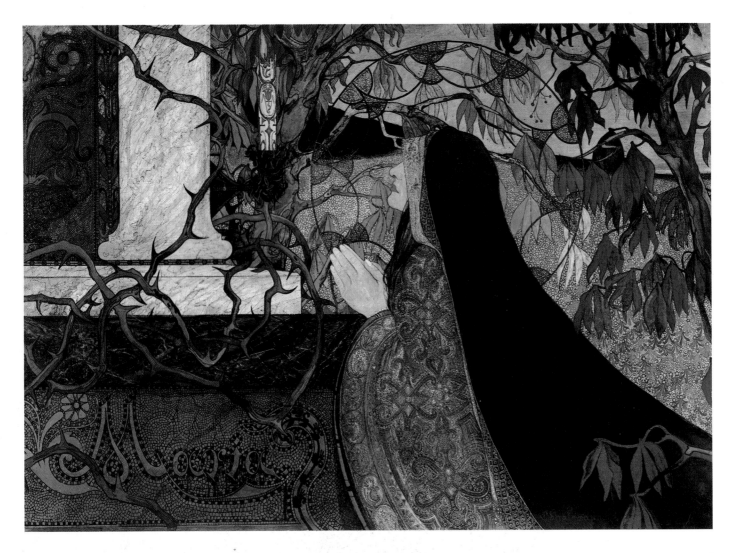

57 Carl Strathmann
Maria, c. **1897**
Oil on canvas. 111 × 157 cm
Weimar, Kunstsammlungen zu
Weimar Schlossmuseum

where he became the central figure of Bohemian life. His work is difficult to fit into any generally accepted category but two features in particular stand out: a combination, characteristic of much 'Stylist Art', of pure and applied art techniques (he was not prepared to admit of a fundamental distinction between the two), and a taste for parody. The head of Medusa

that figures prominently in the art of the turn of the century, for example, is transformed in Strathmann's work into the wrinkled wry face of an old woman with wide open eyes and a crooked nose.

Maria is typical of his approach. The picture is composed of a large number of different flat shapes. The complexity of their outlines coupled with the resemblance that their patterns bear to those of fabrics, mosaics, embroidery, and precious stones, creates a richly decorative texture. It was L. Corinth who said of Strathmann that he concentrated on even the very smallest details so as to be able to endow them with some compositional significance. Like Klimt (Ills. 23-25) he allows decorative requirements to take precedence over

considerations of perspective and spatial depth. Consequently everything in the canvas is incorporated into the flatness of the surface so that it is only by means of the comparatively realistic portrayal of hands and face that we are able to recognize the central figure as a person. The visual interest of the work lies in the richness of its details, in the filigree-like arrangement of shapes which engages the observer's attention.

The influence of the applied arts became even more pronounced in the large flower paintings that Strathmann produced later in his career. The arrangement in rows of identical motifs and their symmetrical alignment along both axes is highly reminiscent of carpet design.

As far as public recognition was concerned, **Stuck**'s career as an artist was an unqualified success; in terms of critical acclaim, however, it can only be accounted a disaster. In 1905, for example, he received from the Bavarian Crown the Knight's Cross of Merit which meant that he was also elevated to the nobility; but in the same period the critics showed themselves to be unrelenting in their hostility to his work. In 1904 a leading German art-historian had described his painting as 'frivolous provincial art' and as 'the greatest achievement of Munich's carnival-inspired renaissance'. Nevertheless, the public, whose enthusiasm for his work continued unabated, showered all kinds of honours upon the man they regarded as the 'Prince of Artists'. He received not only countless medals, prizes, and orders of merit but also offers of honorary membership from academies of art, both at home and abroad.

Though immensely popular during his own lifetime, Stuck's work shared the same fate as that of many other 'Stylist' artists; changing taste consigned it to an oblivion from which it has only recently been rescued. Moreover, the association of his paintings with the National Socialist era, in which they were hailed as a manifestation of the 'strength rooted in the people', has delayed an objective judgement of what he produced.

The works of this founding member of the Munich Secession include caricatures, book illustrations, and designs for furniture, in addition to oil paintings. We do not have to look far to find the key to his popularity with the public; it was based on two of his work's most characteristic features: the accessible manner of its realistic portrayal combined in a Böcklin-like way with elements drawn from Impressionism, Symbolism, and Art Nouveau; and a selection of themes that was readily intelligible to the public.

Between 1889 and 1912 Stuck painted more than ten versions of the painting *Sensuality*, which he also gave the alternative titles of *Sin* and *Vice*. Although relatively well painted and reminiscent at times of Knopff's work, the air of mystery that it attempts to evoke strikes us now as shallow, even vulgar. It is this latter element that undoubtedly appealed to the contemporary observer seeking some outlet for his repressed sexuality. Though Stuck can hardly be regarded as one of the key figures in the development of European art, he did, nevertheless, exert influence through his students, three of whom—Kandinsky, Klee and Albers—became leading artists of the 20th century.

58 Franz von Stuck
Sensuality, c. **1891**
Oil on canvas. 56 × 36 cm
Munich, Gallery Gunzenhauser

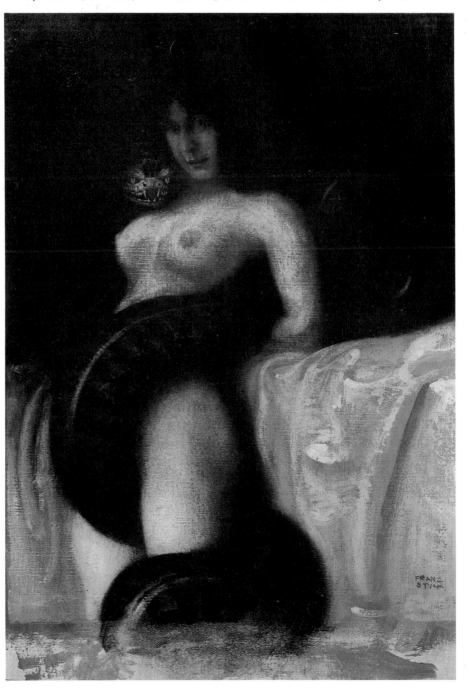

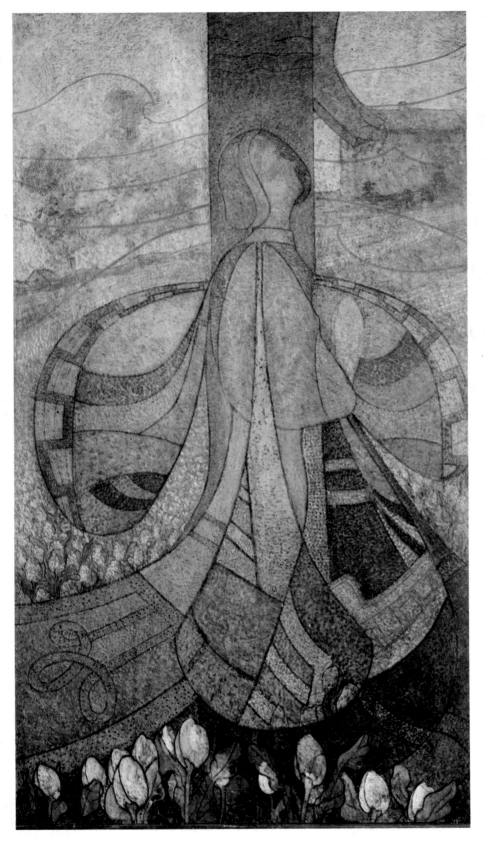

Although a great deal of attention is devoted in art histories to the supposed influence of Toorop (Ills. 61, 62) on **Thorn Prikker**, the latter was probably more influenced in his artistic development by his close friendship with van de Velde. Nevertheless, Toorop, like van de Velde, was a member of Les Vingt and it was at their Salon in Brussels that in 1892 Thorn Prikker's work was exhibited together with that of Signac, Toulouse-Lautrec (Ills. 63, 64), van de Velde, and A. Besnard.

Between 1892 and 1895, using a technique that was pointilliste in its inspiration, he painted mainly religious works. They attracted little attention even in Holland, with the result that the artist readily accepted the offer of a teaching post at the Krefeld School of Applied Arts just over the border in Germany. The two works reproduced here, *Madonna in a Tulip Field* and *Deposition from the Cross*, were both painted in 1892. This same year witnessed many other events that were of great significance in the development of 'Stylist Art'; Crane painted *The Horses of Neptune* and Gauguin his *When Will You Marry?* Hodler's *The Dejected Souls* (1892), Toorop's *The Three Brides* (Ill. 62) and Knopff's *Sphinx* were all to be seen at the first Salon de la Rose + Croix. Stuck, W. Trübner, and F. von Uhde founded the Munich Secession, which marked a reaction against the official art of the academies. Leistikow, M. Liebermann, Klinger, and von Hofmann joined forces to form the Society of the Eleven. Today we refer to this group-forming trend as Secessionism.

The *Madonna in a Tulip Field* and the *Deposition from the Cross* are both distinguished by long, sweeping lines and a pointilliste application of colour. In each case the central figures and objects, such as the madonna and the tulips, or

59 Johan Thorn Prikker
Madonna in a Tulip Field, **1892**
Oil on canvas. 146 × 86 cm
Otterlo, Rijksmuseum Kröller-Müller 90

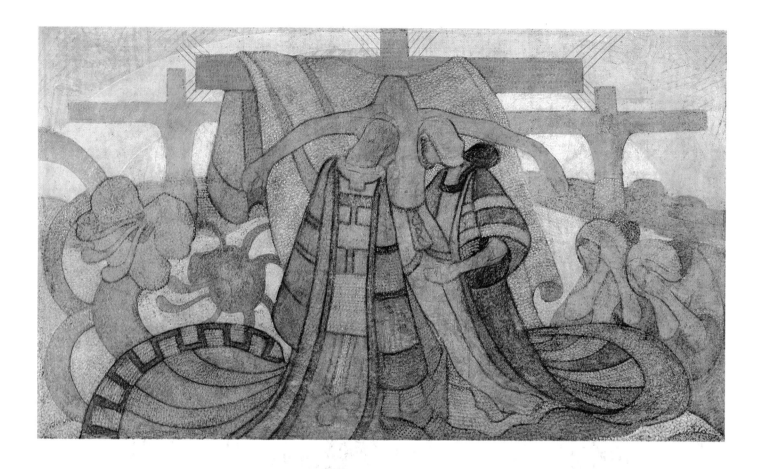

the dead Christ and the crosses, are incorporated into the ascending or descending movement that pervades both canvases. The resulting impression is one of ornate stylization in which decorative considerations outweigh those of representation. This feeling that figures and objects have been reduced to a series of ornamental configurations is further strengthened by the distinctly mesh-like appearance of the surface: spots of colour resembling tiny beads are applied in such a way that they follow and run parallel with the curving lines.

The stylized appearance of the painting results from the flattening of its perspective and the consequent air of insubstantiality that this imparts to the figures. This consistent lack of spatial depth not only ensures unity but also creates an ethereal, almost mystical effect that is entirely in keeping with the religious subject. By thus combining Symbolist and Art

Nouveau elements Thorn Prikker was able to make an important and original contribution to the further development of religious art in the 20th century.

60 Johan Thorn Prikker
Deposition from the Cross, **1892**
Oil on canvas. 88 × 147 cm
Otterlo, Rijksmuseum Kröller-Müller

The emphatically linear organization of *Delftsche Slaolie* and *The Three Brides* is typical of Jan **Toorop**'s mature style; but the creation of what may seem to us

61 Jan Toorop
Delftsche Slaolie, **before 1897**
Colour lithograph. 99 × 70·2 cm

as perfectly organic and natural, did not come easily to the artist. Indeed, it was precisely this inability on Toorop's part to find his own voice as a painter that was singled out in a contemporary review of his work. The critic in question wrote: 'First he painted in exactly the same

fashion as Courbet, and then just as Manet; he surpassed Manet and Pissarro, then Renoir and Degas. He has painted heads, whose outlines remind us of the most wonderful hand drawings to be found in our museums. At the same time he is a Symbolist of the poster-painting variety and a poser of linear riddles. He pursues both ends so fanatically that he exceeds even Hellen, Knopff and those of a similar ilk. Where is "he as himself"? Everywhere or nowhere? He plays twenty-seven instruments in an equally virtuoso fashion, he speaks so many languages with ease that it is impossible to tell which of them is his mother tongue. His work is a representative cross-section of the art produced in the last forty years' (Hofstätter, p. 151).

Toorop was born in Java, but raised in Holland from the age of fourteen. Even before his journeys to Paris and London. Toorop came into contact with some of the finest work of contemporary painters. His time spent as a student at the academy in Brussels enabled him to visit the many exhibitions held by Les Vingt. This organization, which had been founded in 1884 and was later to change its name to La Libre Esthétique, displayed a comprehensive range of modern art. Painters represented included Seurat in 1887 (*La Grande Jatte*, 1884–6), Toulouse-Lautrec in 1888, Gauguin in 1889, and Cézanne and van Gogh in 1890.

The Three Brides shows a mass of figures and objects, dominated by three centrally placed female forms. They are rendered even more conspicuous by the application of white chalk which contrasts sharply with the predominantly dark background. The middle figure is a nude whose body is partially obscured by a veil that reaches from her head to her feet; the figure on the left is dressed in a garment resembling that of a nun or madonna, and the figure on the right is clothed in a similarly transparent robe but with the addition of various accessories such as a chain made up of tiny skulls, leaf-like epaulettes, and two snakes intertwined as a headdress. Toorop himself gave us a

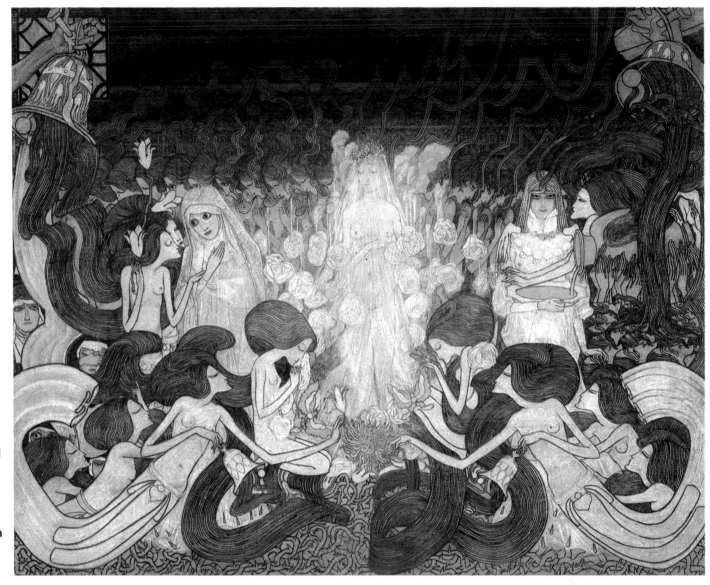

62 Jan Toorop
The Three Brides, **1893**
Pencil, black and coloured crayon on brown paper
78 × 98 cm
Otterlo, Rijksmuseum Kröller-Müller

few clues as to their significance: the middle figure represents the desire for beautiful and noble things; the blossoms 'the delicately stylized forms of young girls', and the two butterflies at her feet are to be interpreted as signs of 'the Eternal Feminine here on Earth'. The figure on the left is the 'mystical bride, white and pure', the one on the right is the bride of the 'world of the senses . . . with a worldly and materialistic expression on her face'. Any further speculation distracts the observer unnecessarily from the painting and its readily intelligible but complex organization. With the excep-

tion of the three central figures all the objects in the painting such as the faces, hair, hands, and bells, gradually dissolve into ornamental flourishes. The women's hair, for example, which takes on the appearance of endless streams of ribbon, turns into the 'lines of sound' (Toorop) issuing forth from the bells. The result is a complex linear pattern distinguished both by its symmetry and by the arrangement of elements in horizontal rows. Using this linearity as a means of orientation, the observer is involved in a seemingly never-ending process of discovery; he notices, for example, that directly adjacent to the

bride on the right more faces are to be seen, and hands holding a jug; or he might notice that behind the three brides there are figures whose hair wafts over the background, the 'sea and the dark impenetrable chaos' (Toorop).

Delftsche Slaolie, an advertisement for salad oil, demonstrates the artist's virtuoso handling of line, which he was able to apply to almost any subject. Here, too, the whole composition is so dominated by a curvilinear design that we are obliged to follow carefully the paths traced by the linear configurations before alighting on the subject: two women preparing a salad.

63 Henri de Toulouse-Lautrec
La Loie Fuller, **1893**
Colour lithography. 61 × 54 cm

Toulouse-Lautrec, who descended from an old noble family and became permanently crippled after a series of accidents, received his first instruction in painting from an old friend of his father, the animal painter R. Princeteau. His precocious gifts had been early recognized and in 1882 he moved to Paris where he quickly completed his training in drawing, painting, and the graphic arts. Although he never really abandoned an Impressionist conception of art, his style does contain new and original features, such as spontaneity of line and an analytical treatment of thematic material, which were to influence his contemporaries. His particular claim to fame, however, rests on the contribution he made to the art of the lithograph—his handling of the medium is such as to surpass his work as a painter.

He drew most of his subject matter from the life of the cabarets, theatres, cafés, and bars in the artists' quarter of Montmartre in Paris, where he had a studio of his own. By means of rapid yet telling strokes and flourishes he succeeded in capturing the likeness of celebrated Parisian figures both of the entertainment world and the demi-monde. He knew how to isolate precisely those movements which were unique to a dancer and consequently expressive of his or her personality. Rather than pander to the indulgent view that society had of itself, he chose in his sketches, drawings, and poster designs to reflect an image that was, as he saw it, nearer to the truth—a vision in which the frenzied but aimless existence of actors, clowns, and prostitutes was a symbol for the meaningless lives led by much of the rest of society.

The dancer and singer Loie Fuller made her debut at the Folies-Bergères in 1892. She was particularly famous for her sinuous dance in which her many veils described sweeping arabesques in the air or reared up like some living, seething embodiment of an external process of transformation. Seizing in his lithograph on the then popular theme of the dancer, the artist reduces the movements of Loie Fuller's body to a series of sweeping lines so that only head and legs remain visible. The poster *La Revue Blanche* was created for the famous Symbolist periodical of the same name. Whereas Toorop (Ills. 61, 62) and van de Velde (Ill. 66) achieve a two-dimensional union of figure and writing, Toulouse-Lautrec prefers to keep their function and appearance quite distinct. In so doing, he created a style for posters that was of considerable influence on other artists working in the genre.

64 Henri de
Toulouse-Lautrec
La Revue Blanche
1895
Colour
lithography
95 **148 × 105 cm**

Like many other of his French contemporaries **Valloton** was also a student at the Académie Julian, where he met and befriended members of the Nabis group. He first made his name as a woodblock engraver, using the medium of the woodcut as a means of social satire; it was not until later in his career that his interest turned to painting. In addition to working for magazines such as the *Revue Blanche* in Paris, *Jugend* in Munich, and *Pan* in Berlin, he was active as a writer both of critical articles (for the *Gazette de Lausanne*, for example) and of original, creative work. 'Now everyone is, or thinks that he is, a mystic or a Symbolist. The energy of past years has now given way to pale, mysterious works, to ghostly or cataleptic paintings, and the need for the quintessential is becoming widespread' (Jullian, p. 31). These words of Valloton were occasioned by the first exhibition of the Salon de la Rose + Croix in 1892 in which the artist himself was represented by a series of drawings. As is quite clear from his painting *Woman Bathing* he cannot, according to his definition of Symbolism, be regarded as one of its most typical representatives. The painting almost startles the observer by confronting him with the image of a naked woman, lying prone on the ground with her face bent over a narrow expanse of water. The impact of the image is heightened by the use of firm contour and by the way in which the emphatic diagonal alignment of the nude dominates the whole canvas. The painting is further distinguished by long, curving lines and the contrast of black and white which the artist had previously used effectively in his woodcuts. The contrast between the red, brown, and green hues of the dark earth and the bright flesh-colour of the nude is played off against the realistically conceived action, the raised feet, and the stylised, Nabi-like landscape.

65 Felix Vallotton *Bathing Woman (The Spring),* **1897 Oil on cardboard 48 × 60 cm Geneva Petit Palais** 96

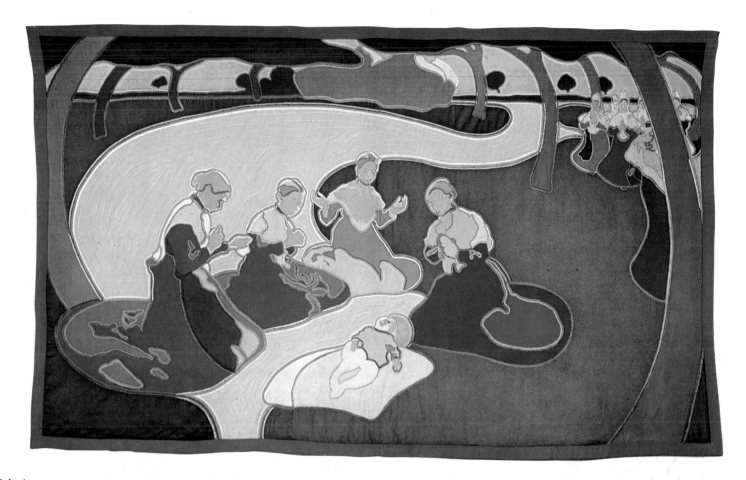

Van de Velde began as a painter of Neo-Impressionist canvases but he later turned his attention to the creative possibilities afforded by other media, such as that of posters or interior design (for S. Bing's 'Art Nouveau' gallery, for example). We can only gain a proper understanding of his work if we consider it in the light of his theories. These developed out of his protest, in the 1890s, against the misuse of traditional methods, and they proved to be highly influential in the subsequent development of 20th-century art. Central to the new theories was the seminal notion that, 'every object which projects its shadow either onto a wall, into the air, or, in short, onto any kind of background, at the same time originates a complementary form whose outline is identical with that of the shadow; and this *negative form* which is just as important as the object itself, enables us to be certain in our judgement of its beauty . . . A line

that in artistic terms is perfect and which functions as the border between two surfaces creates on both sides perfect forms. If, for example, we look at the two lines that represent the right and left extremities of a piece of furniture, then what lies between is concrete. But beyond these boundaries there exists on the wall a complementary shape, a form without substance . . .' (van de Velde, p. 59).

In 1902 he took over the direction of the Weimar Academy and instilled new life into the institution. Obliged to give up his post in 1914, at the outbreak of the First World War, he suggested W. Gropius as a replacement, and so paved the way for the most important institution of modern art—the Bauhaus. In 1925, when he was over sixty, the artist was offered by the Belgian government the directorship of the Institut Supérieur des Arts Décoratifs in Brussels that had been founded for him.

66 Henry van de Velde
Angels Keep Watch, **1893**
Embroidery. 140 × 233 cm
Zurich, Kunstgewerbemuseum

67 Vincent van Gogh
Almond Blossoms, **1889**
Oil on canvas. 73 × 92 cm
Amsterdam, Rijksmuseum
Vincent van Gogh

The paintings which **van Gogh** completed between 1883 and 1885, including, for example, the *Potato Eaters*, are characterized both by a sombreness of mood and by the use of simple, if cumbersome, line. In 1886 he arrived in Paris where repeated contact with the works of the Impressionists, Pointillistes and early Symbolists introduced a brighter note into his palette. For ever in search of more light and greater freedom, he went in 1888 to Arles where he was joined shortly afterwards by his friend Gauguin. Their attempt to found an

artists' community together led to nothing but a series of violent quarrels.

Characteristic of van Gogh's later canvases are their pure colours and sweeping, often broken lines, which anticipate the use of similar devices in art at the turn of the century, in the late landscapes of Klimt, for example, or in Expressionist painting.

It is van Gogh himself who sheds the best light on the simple yet expressive symbolism of his landscapes: 'I see in the whole of nature, in trees, for example, expression, even soul. I have tried to invest

my landscapes, as well as my human figures, with the same feelings: a frenzied and passionate embrace of the earth that only storms can relax. I wanted to express something of life's struggle in this' (Hess, p. 24).

68 Vincent van Gogh
Meadow with Flowers, **1890**
Oil on canvas. **72** × **90 cm**
Otterlo, Rijksmuseum Kröller-Müller

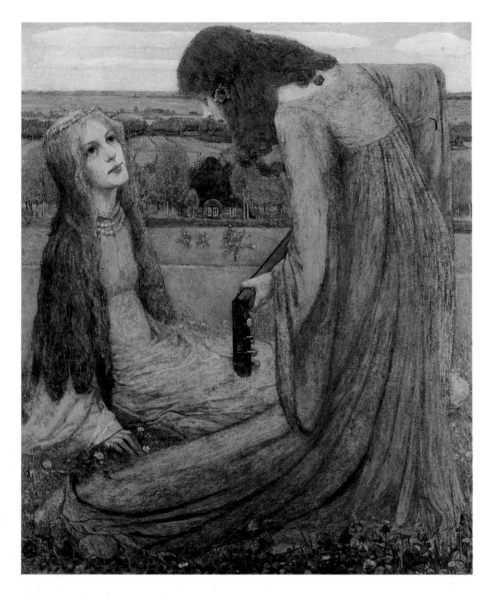

Vogeler's conviction that art should be an intimate part of everyday life led to his founding, in 1908, the Worpswede work-shops for farmhouse furniture.

His painting *The Annunciation* betrays not only the influence of the Pre-Raphaelites (in the gentle application of colour, and in a corresponding fineness of detail, in the clover in the foreground, for example), but also the linearity of Art Nouveau. In his Worpswede monograph of 1902–3, R. M. Rilke wrote the following passage about the painting: 'The angel bringing the message does not frighten the young girl. He is the guest whom she has been expecting. She receives him warmly, like a door flung wide open, and is entirely receptive to his words. And the great angel bends over her, singing so close to her that she cannot fail to catch every one of his words; and the folds of his sumptuous clothing still show the movement with which he bent down to greet her. Now his heaven is far away, and only the earth is there and we can see a long way into its tranquil heart. This paint-ing is filled in every part of its surface with a restful, well-proportioned beauty, with a radiance and bounty. We feel that this artist approached the subject matter of the Bible in his own way; when giving visual expression to its words, he does not paint them as miracles but rather as auspicious events, which enrich our lives and lend significance to them' (Rilke, p. 148).

69 Heinrich Vogeler
The Annunciation, **1901**
Oil on canvas. 100 × 85 cm
Arnsberg (Westphalia)
G. Schmale Collection

The two most important artists' centres on German soil at the turn of the century were at Worpswede and Neu-Dachau near Munich. Although most of the resident painters devoted themselves to the repre-sentation of moorland ·scenes and the simple life of the peasants, **Vogeler**'s principal interest was drawing. After a period of study at Düsseldorf, the artist came to Worpswede where he had bought his own estate. Typical of his work were the illustrations for fairy-tales that he did in the 'nineties. Though they are closely modelled on Beardsley, they undoubtedly rank as some of the finest contributions made by Art Nouveau to this genre. Birds with fantastic plumages that merge into flowers and fruits; blossoms, from which new blossoms spring, are like beautiful curtains that have obscured reality.

The Intimiste **Vuillard** shared a studio with Bonnard (Ill. 7); he was present at the famous Tuesday meetings held at the home of Mallarmé; he took part in events organized by the editorial staff of the *Revue Blanche*, where he also met van de Velde (Ill. 66) and Munch (Ill. 43). He was responsible for part of the interior decoration of the Théatre de l'Oeuvre. As a member of the Nabis group, he maintained close contact with the friends of his youth such as Denis, Sérusier, Valloton, and Maillol. His work, like that of Bonnard, is particularly notable for its portrayal of cosy domestic scenes.

In his painting *The Park* we are confronted with an ornamental pattern of different colours into which the artist has placed—almost timidly it seems—objects and figures. The fact that their definition remains unclear, or that their arrangement is asymmetrical, only adds to the impression of life which they give. The lack of spatial depth further obscures the distinction between the representational and the decorative features. By the skilfull juxtaposition of isolated, apparently random, elements with others that are repeated, the artist creates a work which seems natural and true to life.

And yet it would be a mistake to think that this realism was of the same order as, say, that of Millais. While the latter aims at photographic exactitude, Vuillard juxtaposes scenes from everyday life with more abstract elements such as ornamental flattening of perspective and the use of colours so finely graded that they cease to serve a purely representational function, acquiring instead the status of an independent decorative feature. The consequence of this is that the subject and the action it entails are incorporated into the ornamental framework as a static element. The observer is therefore obliged to supply a narrative sequence of his own devising based on what he can already see.

70 Edouard Vuillard
The Park, **1894**
Tempera on canvas. 213 × 307 cm
Paris, Musée Nationale
d'Art Moderne

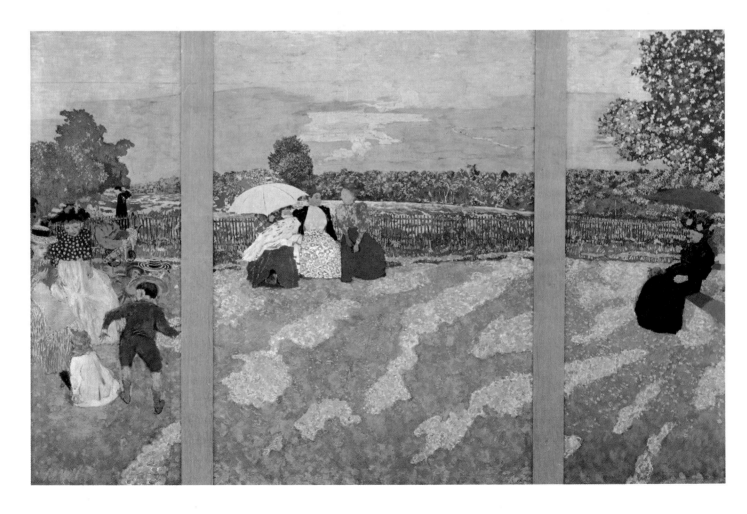

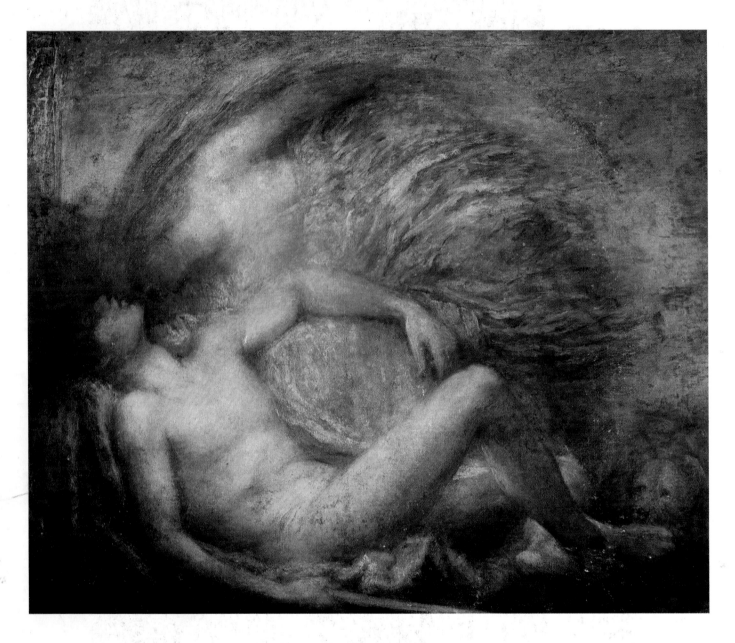

71 George Frederick Watts
Endymion, **1869 and 1903**
Oil on canvas. 104 × 122 cm
Compton (Surrey), Watts Gallery

Endymion was sleeping one night in a cave on Mount Latmos when Selene, who was the goddess of the moon (the Roman Diana, the huntress, hence the dog in the bottom right hand corner), caught sight of him for the first time. In love with him, she came down to earth and kissed him on the eyes. According to the legend, Endymion, who was never to wake again, had been thus endowed with eternal youth. **Watts**, the painter of *Endymion*, was already at seventeen a pupil of the Royal Academy, and later became a member of it. Even during his lifetime he was famous for his allegorical and visionary works of which he himself particularly prized *Hope* (1885) and *The Sower of the Cosmos* (1872).

Behind the reposing youth one can see the top half of a large circular form, bluish-green in colour and blurred towards the edges. The circle, within which there are suggestions of the head, the naked upper torso, and the arm of the moongoddess, is completed by the shoulder, arm, and foot of Endymion. His head lies outside the circle and is balanced by the head of the dog, thus emphasizing the circle's dominating position on the canvas. Endymion's staff, which is cut by the frame, leads the eye up towards the circle and thus into the whirlpool of colour and half-suggested 102

forms at the centre. The almost square format forces the lover and the beloved into close proximity, thus increasing the sense of intimacy. The blurring of forms and colour produces an almost visionary intensification of the scene's nocturnal mystery.

Although he was born in Massachusetts (USA), **Whistler** certainly ranks as a European artist. He visited London for the first time at the age of twenty-one, and after a period of study in France, he returned to the city in 1859 and remained there permanently. He was one of the first (along with Rossetti) to appreciate the subtle qualities of Japanese art.

Committed as he was to the ideals of the Aesthetic Movement, which saw beauty and harmony as being prerequisites of all artistic endeavour, he gave many of his paintings musical titles such as *Miss Cicely Alexander, harmony in Grey and Green* (1872–4). After 1870 he came to regard himself primarily as a portrait painter. It was at this period that he created *Nocturne in Blue and Silver: The Lights of Cremorne* (1870–2).

The oil study *Young Girl with Almond Blossoms* reveals Whistler not only as a master of well balanced compositions but also as a painter who has no difficulty in creating an elegant union of symbolic subject matter and relatively realistic portrayal. The young girl with her red headscarf and thin veil-like dress is the subject of a painting whose simplicity is as stimulating for the mind as it is for the eye.

72 James Abbot McNeill Whistler
Young Girl with Almond Blossoms
c. **1867–72**
Oil on canvas. 139 × 74 cm
103 **London, Private Collection**

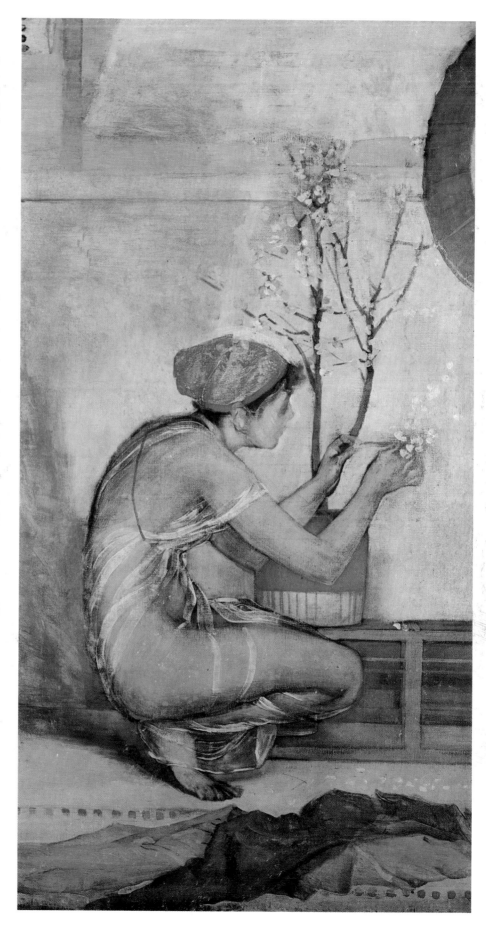

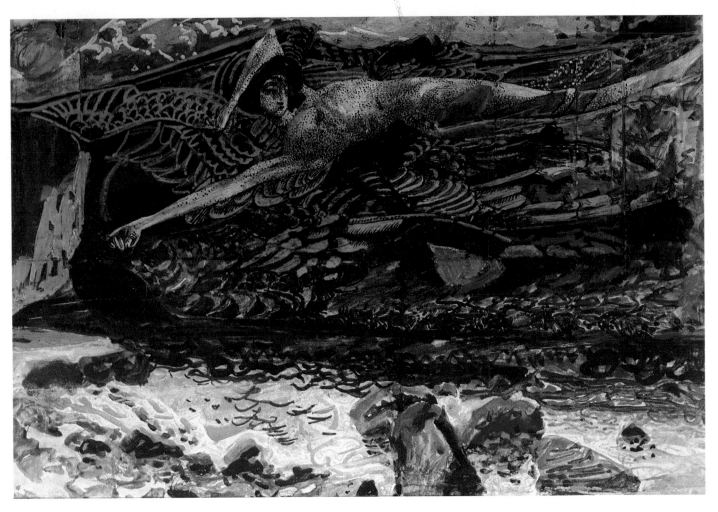

73 Michael Alexandrovich Vrubel
The Fallen Demon, **1901**
Watercolour, gouache
bronzecolour. 21 × 30 cm
Moscow
National Pushkin
Museum of Art

What W. Brjussow said in a poem of 1909 ('and everywhere there appeared a style distinguished equally by its bright colours and audacity—Art Nouveau') applies also to artistic trends in Russia, although here the style was more eclectic, being an amalgam of elements drawn from the Rococo and Empire styles as well as from folk art and Old Russian art.

One of the first to paint in this style was **Wrubel**. Inspired by Toorop and Khnopff and using elements of the Russian iconographical tradition, he depicted religious themes drawn from the realms of Russian legend and fairy-tale. Into these he introduced a modern decadent note reflecting a neurotic sensibility and a barely suppressed fear of life. It is particularly on account of his ceramics, which are embellished with slender, exquisitely bejewelled nymphs, that he deserves to be regarded as a significant representative of Art Nouveau.

The Fallen Demon is a preliminary study for the painting of 1902 on the same subject. The scale-like appearance of the surface renders the painting almost unintelligible until its function is explained by the demon's wings. The mythical quality of the subject matter is rendered even more oppressive and ominous by the combination of steely blue and bluish-white hues with suggestions of pink.